COOL SPOTS
LAS VEGAS

teNeues

Imprint

Editor: Patrice Farameh

Editorial coordination: Nadine Maren Schoenweitz, Anne Dörte Schmidt

Photos: Courtesy MGM Mirage (55° Wine + Design, 10–13; BATHHOUSE at THEhotel, 14–17; Mix 72–75; SKYLOFTS 98, 99; Stack 105; THEhotel 116–121; The Reading Room 122, 123), courtesy Body English (Body English 18, 20, 21), courtesy Four Seasons Hotels and Resorts (Four Seasons Hotel Las Vegas 38), courtesy Hard Rock Hotel, Las Vegas (Hard Rock Hotel & Casino 44–47), courtesy Ice (Ice 54–57), Gavin Jackson (Little Buddha 68, 69), courtesy Maverick Helicopters (Maverick Helicopter Tours 70, 71), courtesy Lake Las Vegas Resort (Montelago Village 76–79), courtesy Palms (Palms Spa & Pool 81, 82; Palms Themed Suites 86–91), courtesy Grand Canyon West (Skywalk 100, 101), courtesy Warren Jagger (Tao Asian Bistro 106–109), courtesy The Fashion Show (The Fashion Show 111), courtesy The Forum Shops (The Forum Shops 114, 115)
All other photos by Martin Nicholas Kunz

Introduction: Patrice Farameh

Layout & Pre-press: Martin Nicholas Kunz, Anne Dörte Schmidt

Imaging: Jan Hausberg

Translations: Adria Sprachenservice

Produced by fusion publishing GmbH, Stuttgart . Los Angeles www.fusion-publishing.com

Published by teNeues Publishing Group

teNeues Verlag GmbH + Co. KG
International Sales Division
Speditionsstr. 17
40221 Düsseldorf, Germany
Tel.: 0049-(0)211-994597-0
Fax: 0049-(0)211-994597-40

teNeues Publishing Company
16 West 22nd Street
New York, NY 10010, USA
Tel.: 001-212-627-9090
Fax: 001-212-627-9511

teNeues Publishing UK Ltd.
P.O. Box 402
West Byfleet
KT14 7ZF, Great Britain
Tel.: 0044-1932-403509
Fax: 0044-1932-403514

teNeues France S.A.R.L.
4, rue de Valence
75005 Paris, France
Tel.: 0033-1-55766205
Fax: 0033-1-55766419

teNeues Ibérica S.L.
c/Velázquez, 57 6.° izda.
28001 Madrid, Spain
Tel.: 0034-(0)-657 13 21 33

teNeues
Representative Office Italy
Via San Vittore 36/1
20123 Milan
Tel.: 0039-(0)-347-76 40 551

Press department: arehn@teneues.de
Phone: 0049-(0)2152-916-202

www.teneues.com

ISBN-10: 3-8327-9152-3
ISBN-13: 978-3-8327-9152-0

© 2006 teNeues Verlag GmbH + Co. KG, Kempen

Printed in Italy

Bibliographic information published by Die Deutsche Bibliothek.
Die Deutsche Bibliothek lists this publication in the Deutsche Nationalbibliografie; detailed bibliographic data is available in the Internet at http://dnb.ddb.de.

Contents Page

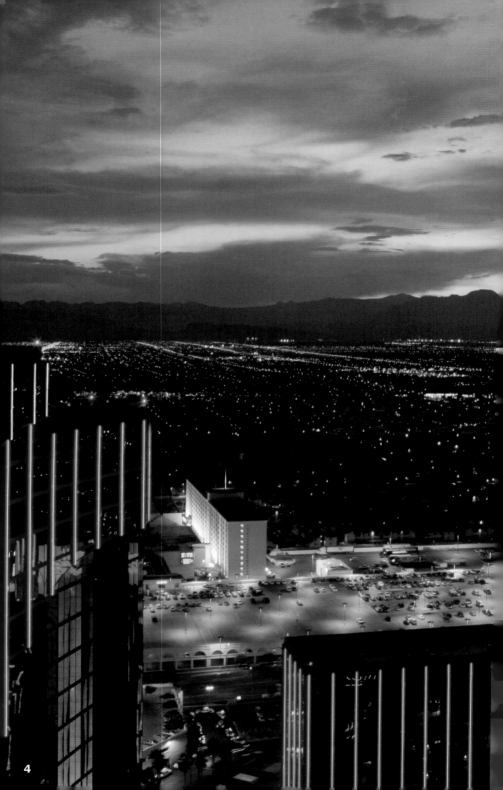

Introduction

It's not a secret that gambling is the main attraction of Las Vegas and everything in its vicinity is just window dressing to lure money to their casinos. But in its ambitious quest to become the leading travel destination in the world, Vegas has become more than an adult Disneyland-like shrine built for greed and love of lucre. It has become an alternate universe never short on entertainment options. It is the coolest place for voguish scene spots and high-intensity entertainment venues, all competing with one another for the ultimate hip audience.

Las Vegas is the quintessential test market for any trendsetting endeavor in the nightlife scene; there is an abundance of major spaces that are backed by their insanely rich landlords. The latest hot trend born out of the nation's entertainment capital bets on two new twists to the entertainment experience. One is the ultra lounge, a glamorous cocktail lounge/dance club hybrid. This cleverly packaged breed of upscale cool spots to lounge, dine, and drink is for those who crave a more mature, sophisticated atmosphere, such as the Little Buddha in the Palms. The second development comes from the pool areas, such as the one at the Hard Rock, that is transformed into outdoor day-clubs where guests can relax on lounges or dance to DJs who spin under the desert sun. All present something new, unique, or fashionable.

The hippest places in Las Vegas mix elegant drinks and snacks with an air of hip exclusivity. A chic, discriminating environment will keep prospective patrons clamoring to get in. Recent cool additions to the scene also include the mega-fusion restaurant/bar/nightclub Tao Asian Bistro in the Venetian. Behind its glittering façade, its lack of being an intellectual city has made up for being the most entertaining one. One thing is for sure: this is not a cultural vacation, but a place to escape and leave all touchstones with reality behind.

Patrice Farameh

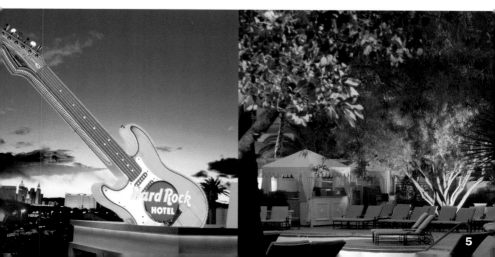

Einleitung

Es ist kein Geheimnis: Glücksspiel ist die Hauptattraktion in Las Vegas und das ganze Drumherum nur Schaufensterdekoration, um Geld in die Spielcasinos zu locken. Doch bestrebt, das führende Reiseziel der Welt zu werden, ist Las Vegas heute mehr als eine Kultstätte der Geldgier und Gewinnsucht in einer Art Disneyland für Erwachsene. Es ist ein sich ständig änderndes Universum der niemals endenden Vergnügungsmöglichkeiten. Hier findet man die coolsten Szene-Treffs und die Stätten des absoluten Entertainments, die alle um die Gunst des ultimativ schicken Publikums buhlen.

Wer sich als Trendsetter in der Nightlife-Szene profilieren will, kommt um Las Vegas als Testmarkt nicht herum; irrsinnig reiche Besitzer investieren in eine Vielzahl riesiger Grundstücke. Der neueste, brandheiße Trend, den die Hauptstadt der Unterhaltung hervorgebracht hat, setzt auf zwei Entwicklungen in der Branche.

Die eine ist die Ultra-Lounge, eine glamouröse Kreuzung aus Cocktail-Lounge und Tanzclub. Diese raffinierte Kombination aus coolen Treffs zum Faulenzen, Essen und Trinken auf hohem Niveau wendet sich an die Klientel, die sich nach einer eher ausgereiften, anspruchsvollen Atmosphäre wie im Little Buddha im Palms Resort sehnt. Die zweite Neuentwicklung kommt aus dem Pool-Bereich, wie beispielsweise dem des Hard Rock Hotels. Die Badelandschaften verwandeln sich tagsüber in Clubs unter freiem Himmel, wo die Gäste sich auf Liegen erholen oder zur Musik tanzen können, die die DJs unter der Wüstensonne auflegen. Sie alle sind neu, einzigartig und modern.

Die angesagtesten Lokale in Las Vegas verbinden ausgefallene Drinks und Snacks mit einem Flair schicker Exklusivität. Ein außergewöhnliches, erlesenes Ambiente – künftige Gäste werden lautstark Einlass begehren. Zu den jüngsten Errungenschaften der Szene gehört auch das Tao Asian Bistro, die Mega-Fusion von Restaurant, Bar und Nachtklub im Venetian Resort.

Hinter seiner glitzernden Fassade ist Las Vegas keine Kulturstadt, aber die Stadt mit dem höchsten Unterhaltungswert. Eines ist sicher: Las Vegas ist nicht das Ziel einer Bildungsreise, sondern ein Ort, um auszubrechen und den Bezug zur Wirklichkeit zu verlieren.

Patrice Farameh

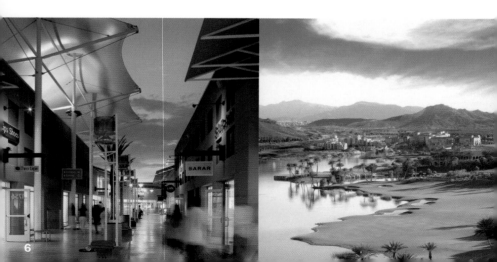

6

Introducción

No es ningún secreto que el juego es la principal atracción de Las Vegas, y todo lo que la rodea es meramente un decorado cuyo objetivo es atraer dinero hacia sus casinos. Sin embargo, en su ambiciosa lucha por transformarse en el principal destino turístico del mundo, Las Vegas es hoy día algo más que un mero santuario al mejor estilo Disneylandia –pero para adultos– construido para la avaricia y el afán de lucro. Se ha transformado en un universo alternativo al que nunca le faltan opciones de entretenimiento. Es el lugar más en boga para escenarios de moda y lugares de entretenimiento intenso, todos los cuales compiten entre sí para atraer a la audiencia más sofisticada.

Las Vegas es el mercado de prueba por excelencia para todo emprendimiento en el escenario de la vida nocturna destinado a marcar tendencia; abundan los espacios amplios respaldados por sus locadores, desmesuradamente ricos. La última tendencia de moda nacida de la capital nacional del entretenimiento apuesta a dos nuevas vueltas de tuerca en la experiencia en esta materia. Una de ellas es el *ultra lounge*, un híbrido glamoroso entre un bar de tragos y una discoteca. Esta inteligente cruza de lugares para pasar el tiempo, cenar y tomar un trago destinados al público de altos ingresos, está destinada a los que anhelan una atmósfera más madura y sofisticada; un ejemplo de ello es el Little Buddha en el Palms. La segunda innovación proviene de la zona de piscinas, como la del Hard Rock, transformada en clubes diurnos al aire libre en los que los pasajeros pueden descansar o bailar al son de la música que los DJ programan bajo el sol del desierto. Todos presentan algo novedoso, único o de última moda.

Los lugares más sofisticados de Las Vegas combinan bebidas y comidas elegantes con un aire de sofisticada exclusividad. Un entorno *chic* y distintivo hará que los potenciales clientes rueguen poder ingresar. Algunas incorporaciones a la escena incluyen también el restaurante/bar/club nocturno mega-fusión Tao Asian Bistro en el Venetian.

Tras su destellante fachada, su falta de intelectualidad se compensa con el hecho de ser la ciudad más entretenida. Algo es seguro: no se trata de un lugar cultural para ir de vacaciones, sino para escapar y dejar tras de sí toda conexión con la realidad.

Patrice Farameh

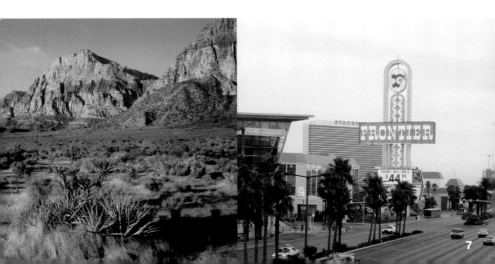

Introduction

Il est bien connu que les jeux représentent l'attraction principale de Las Vegas et que tout à proximité est une façade destinée à attirer l'argent vers ses casinos. Toutefois, dans sa quête ambitieuse de devenir la première destination du monde, Las Vegas est devenue plus qu'un lieu de pèlerinage aux allures d'un Disneyland pour adultes, construite pour l'avidité et la passion du gain. Las Vegas est devenue un univers à part renouvelant toujours ses divertissements. C'est un emplacement de premier choix pour les évènements branchés et les lieux de divertissements extrêmes, tentant chacun d'avoir le privilège de l'audience la plus branchée.

Las Vegas représente le principal marché test pour tout secteur tentant d'innover dans le milieu du divertissement nocturne ; il existe des lieux majeurs en abondance, lesquels sont aux mains de riches propriétaires. La dernière trouvaille en vogue dans la capitale du divertissement mise sur deux nouveaux développements en matière de loisirs. L'un d'eux est un mélange entre un club discothèque associé au glamour d'un bar à cocktails, comme c'est le cas à l'ultra lounge. C'est le type de séjour intelligent réunissant les endroits agréables pour se reposer, dîner et boire pour ceux qui recherchent une atmosphère plus sophistiquée et plus mûre, telle qu'on peut la trouver au Little Buddha du Palms. Le second développement concerne la zone des piscines, à l'instar de celle de Hard Rock, transformée en club diurne en extérieur, où les clients peuvent se prélasser ou danser sous le soleil du désert aux sons des DJ. Tous ces lieux présentent quelque chose de nouveau, d'unique et en vogue.

Les lieux les plus en vue de Las Vegas mélangent les boissons élégantes et les snacks dans une ambiance d'exclusivité. C'est un environnement chic et raffiné, qui entraînera des clients éventuels à clamer haut et fort qu'ils veulent y entrer. Les ajouts branchés à la scène incluent le restaurant-bar-discothèque Tao Asian Bistro du Venetian.

Derrière sa façade à paillettes, Las Vegas, à défaut d'être réputée comme ville intellectuelle, continue d'être la ville la plus divertissante. Une chose est sûre : ce ne seront pas des vacances culturelles, mais le but y est d'échapper au quotidien et de laisser la réalité derrière soi.

Patrice Farameh

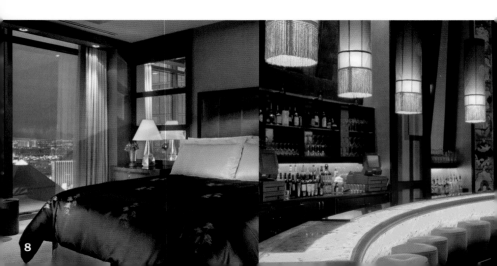

Introduzione

Non è un segreto che il gioco d'azzardo è l'attrazione principale a Las Vegas, e che tutto ciò che vi ruota attorno è semplicemente uno specchietto per le allodole per attirare denaro nei suoi casinò. Ma nella sua ricerca ambiziosa per diventare la principale destinazione turistica nel mondo, Vegas è diventata qualcosa di più di un tempio per adulti simile a Disneyland costruito per l'avidità e l'amore per il lucro. Vegas è diventata un universo alternativo, mai a corto di scelte per quanto riguarda l'intrattenimento. È l'ambiente più straordinario per i locali alla moda e per i posti che offrono intrattenimento ad alta intensità, tutti in competizione fra di loro per il pubblico più trendy.

Las Vegas è il mercato di prova per eccellenza per qualsiasi tentativo di trendsetting nel mondo della vita notturna; c'è un'abbondanza di spazi importanti finanziati da proprietari follemente ricchi. L'ultimo trend nato nella capitale Americana dell'intrattenimento scommette su due nuove sviluppo nell'esperienza del divertimento. La prima è l'ultra lounge, un ibrido di cocktail lounge/dance club. Questa tipo ben confezionato di scenari aristocratici e fantastici dove rilassarsi, cenare e bere è adatto a coloro che desiderano un'atmosfera più matura e sofisticata, come ad esempio il Little Buddha nel Palms. Il secondo sviluppo proviene dalla zona delle piscine, come quella dell'Hard Rock, la quale viene trasformata in un club diurno all'aperto dove gli ospiti possono rilassarsi o ballare al ritmo dei DJ sotto il sole del deserto. Tutto offre qualcosa di nuovo, unico o alla moda.

I posti più in voga a Las Vegas uniscono drink e snack eleganti con un'atmosfera di esclusività trendy. Un ambiente chic e discriminante che provocherà una ressa tra gli aspiranti clienti che vogliono entrare. Le recenti aggiunte includono anche il ristorante/bar/night club mega-fusion Tao Asian Bistro nel Venetian.

Dietro la sua luccicante facciata, il fatto di non essere una città intellettuale è stato compensato dal suo essere la più divertente. Una cosa è sicura: questa non è una vacanza culturale, ma un luogo dove evadere e lasciarsi alle spalle ogni contatto con la realtà.

<div align="right">Patrice Farameh</div>

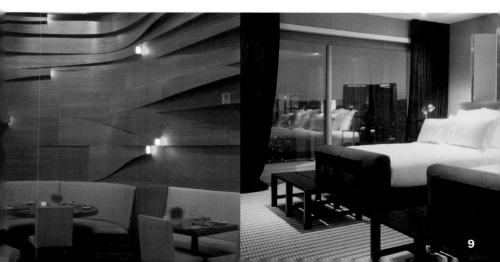

55° Wine + Design

Design: Jones & Greenwold

3950 S Las Vegas Boulevard | Las Vegas, NV 89119 | Mandalay Place
Phone: +1 702 632 9355
www.mandalaybay.com
Opening hours: Sun–Thu 10 am to 11 pm, Fri–Sat 10 am to midnight
Special features: Wine Tasting with over 1,500 selections in futuristic setting

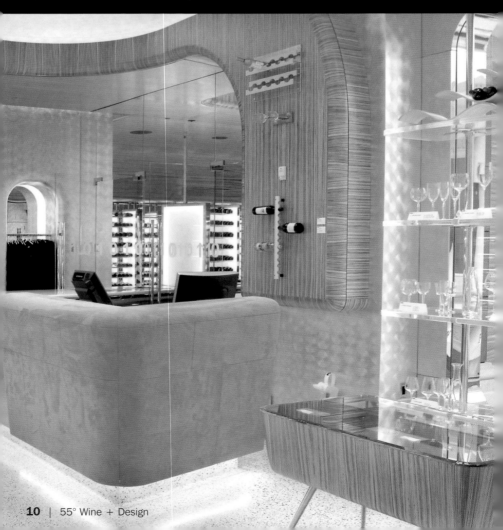

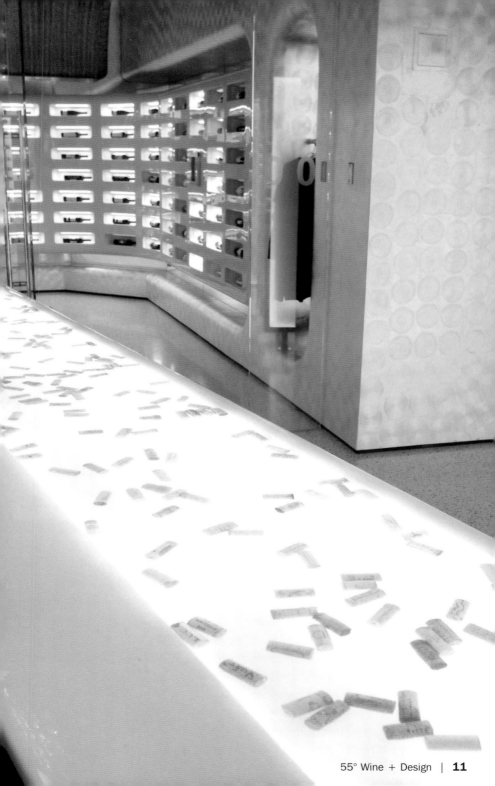

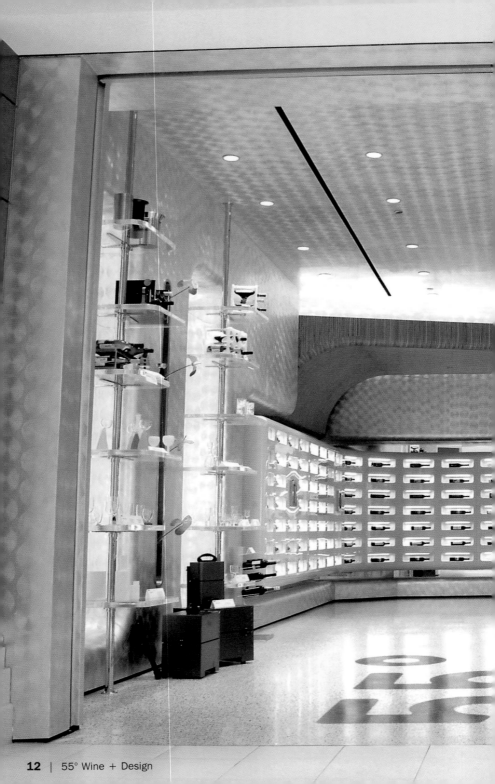

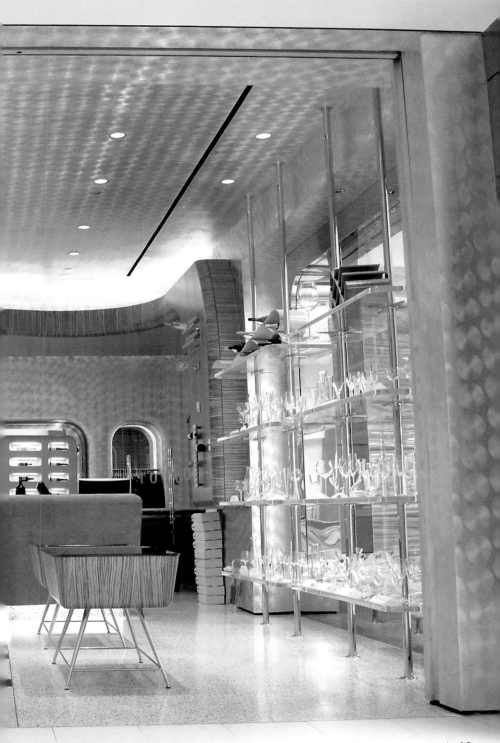

BATHHOUSE at THEhotel

Design: Richardson Sadeki

3950 S Las Vegas Boulevard | Las Vegas, NV 89119 | Mandalay Bay
Phone: +1 877 632 9636
www.mandalaybay.com
Opening hours: Daily 6 am to 8:30 pm
Special features: 14,000-sq-ft spa with state-of-the-art personalized services, such as Hangover Recovery Therapy

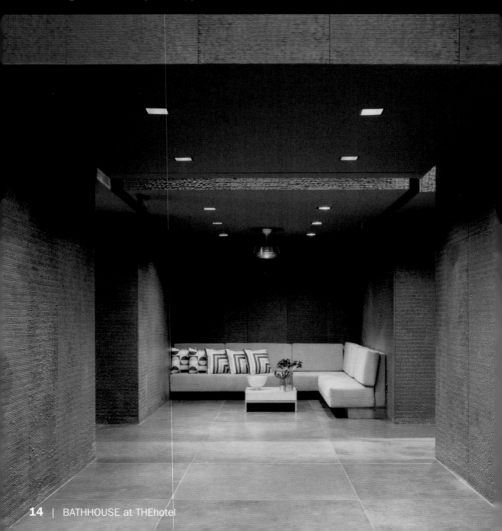

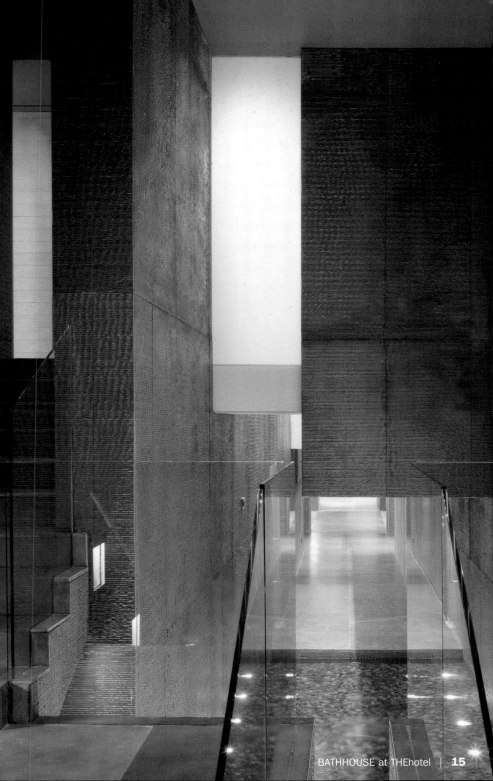

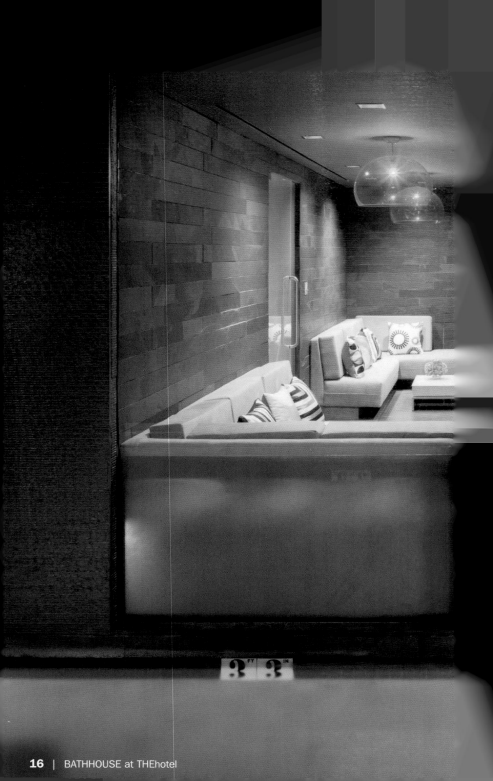

CHILDREN 12 YEARS OF AGE
OR YOUNGER MUST BE
ACCOMPANIED BY AN ADULT.
THE MAXIMUM RECOMMENDED
TIME FOR SUCH CHILDREN TO
USE THE SPA IS 10 MINUTES.

CAPACITY DIAL 911 CAUTION

17 MAXIMUM NUMBER OF PEOPLE
ALLOWED IN THE SPA AT ONE TIME.

Body English

Design: Kelly Wearstler

4455 Paradise Road | Las Vegas, NV 89169 | Hard Rock Hotel
Phone: +1 702 693 4000
www.bodyenglish.com
Opening hours: Fri–Sun from 10:30 pm to 4 am
Special features: Rock Star decor with ultra-exclusive-VIP area where VIPs can
secretly view the action in the club without being seen

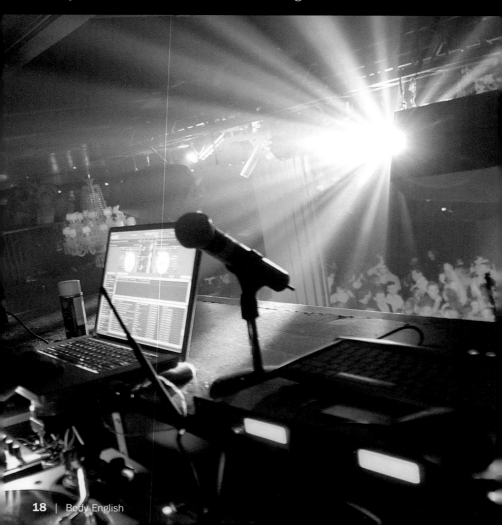

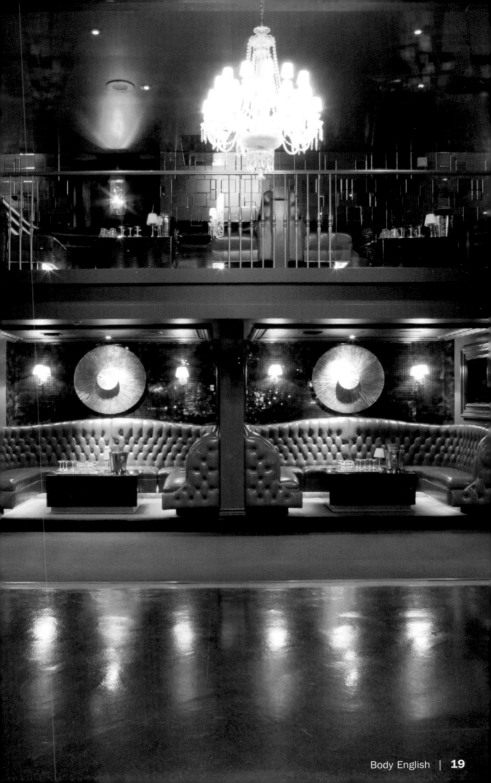

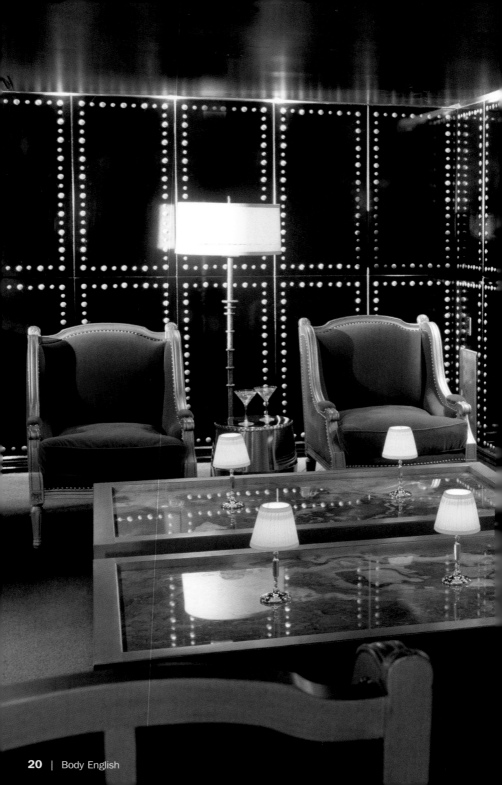

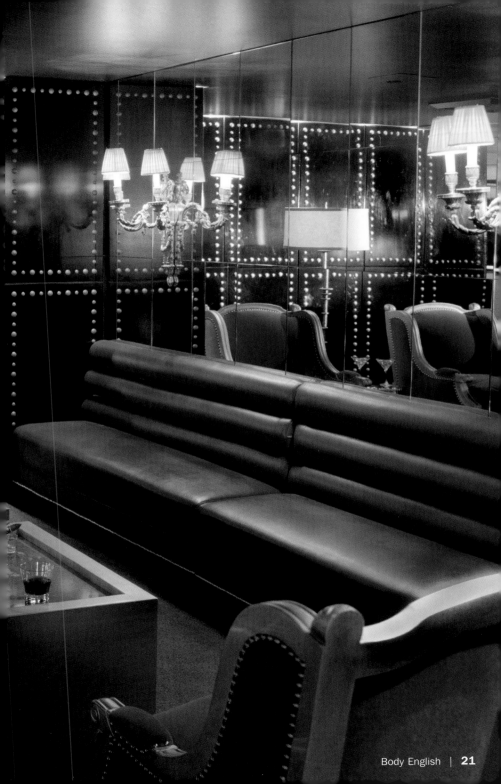

Chrome Hearts

Design: Richard Stark with Mark Steele FAIA

3500 S Las Vegas Boulevard | Las Vegas, NV 89109 | The Forum Shops
Phone: +1 702 893 9949
www.chromehearts.com
Opening hours: Sun–Thu 10 am to 11 pm, Fri–Sat 10 am to midnight
Special features: Boutique in ultra chic setting offering the most exclusively hip
leather and sterling silver luxury goods on the market

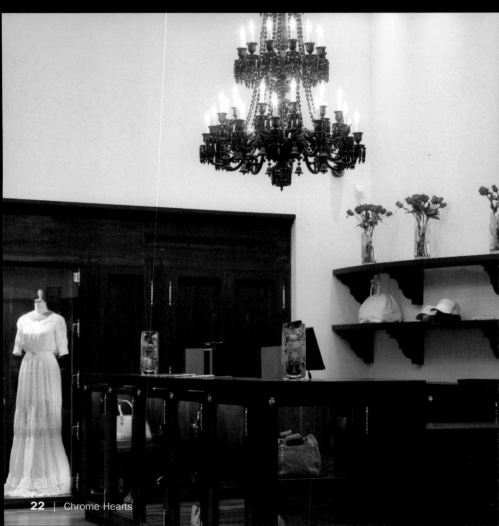

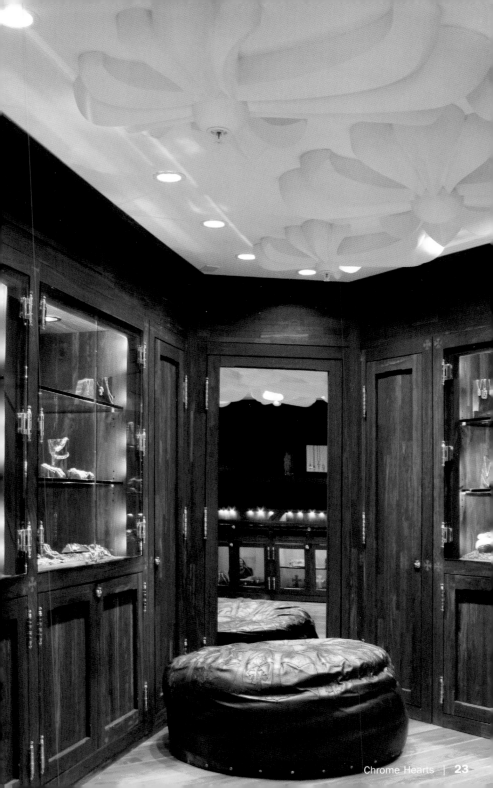

Desert Passage

Friedmutter Group/Gensler

3663 S Las Vegas Boulevard | Las Vegas, NV 89109 | Aladdin
Phone: +1 888 800 8284
www.desertpassage.com
Opening hours: Sun–Thu 10 am to 11 pm, Fri–Sat 10 am to midnight
Special features: 170 stores and 15 restaurants set in the ambience of an open-air
Mediterranean market with hourly indoor storm show

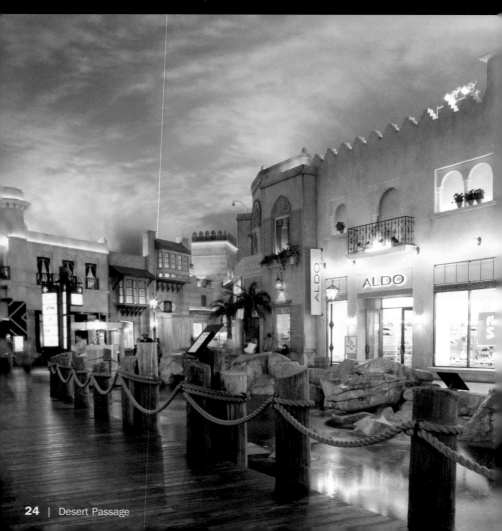

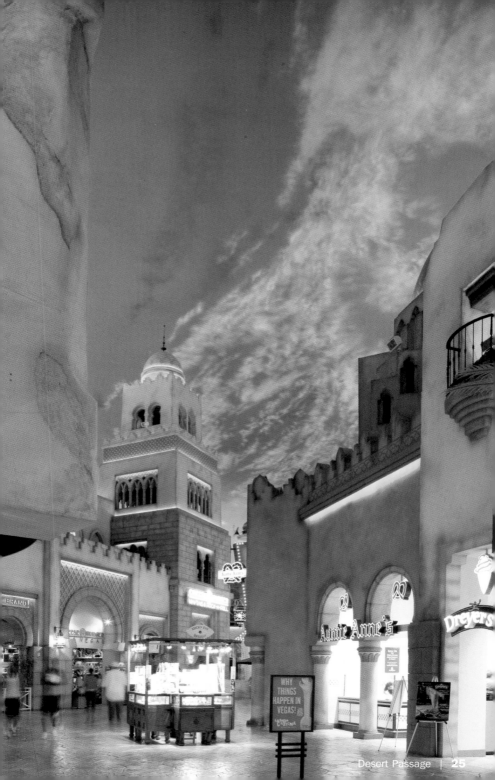

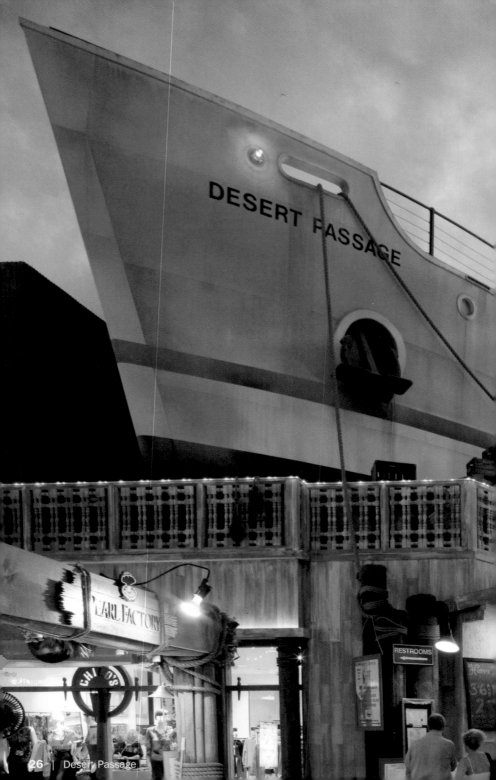

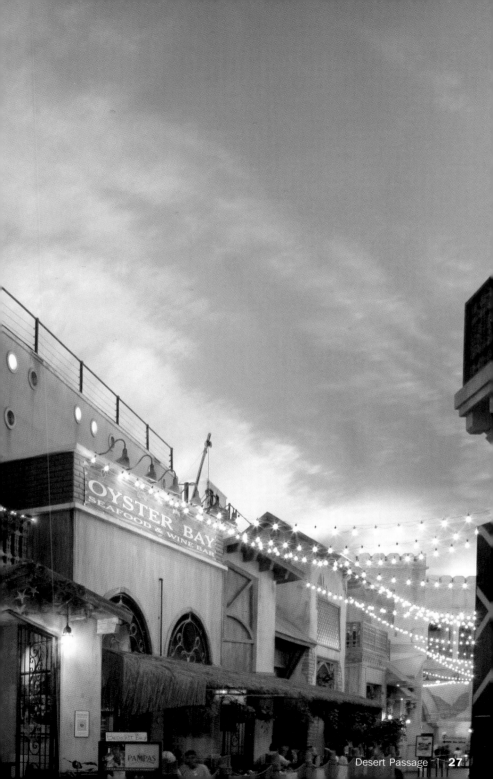

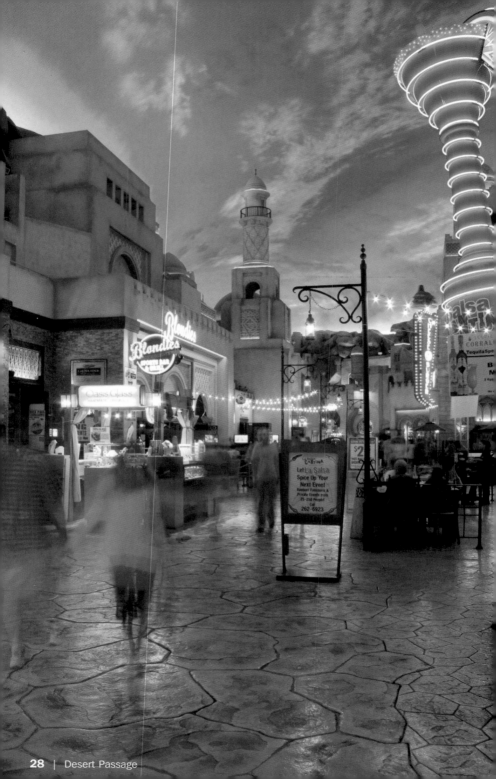

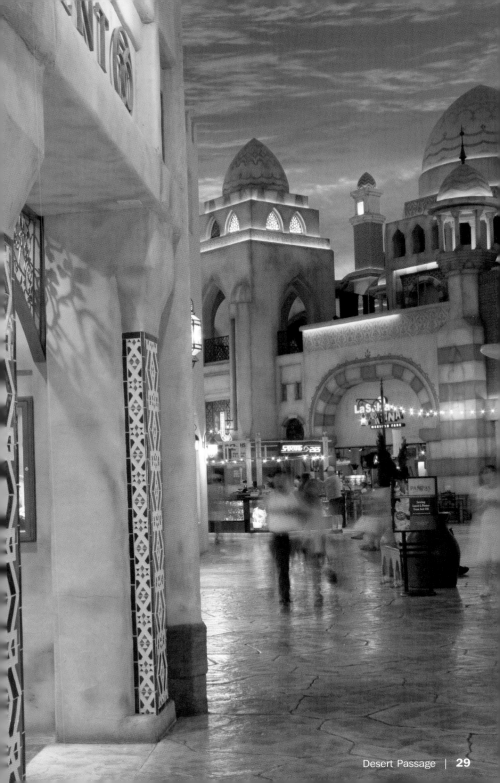

Drai's

Paintings by Pierre A. Marcand, after "Vargas" and "de Lempicka"

3595 S Las Vegas Boulevard | Las Vegas, NV 89109 | Barbary Coast
Phone: +1 702 737 0555
www.drais.net
Opening hours: Restaurant daily 5:30 pm to 10 pm, Club Drai afterhours Wed–Sun
from midnight to open end
Special features: Exotic underground French restaurant with after-hours nightclub

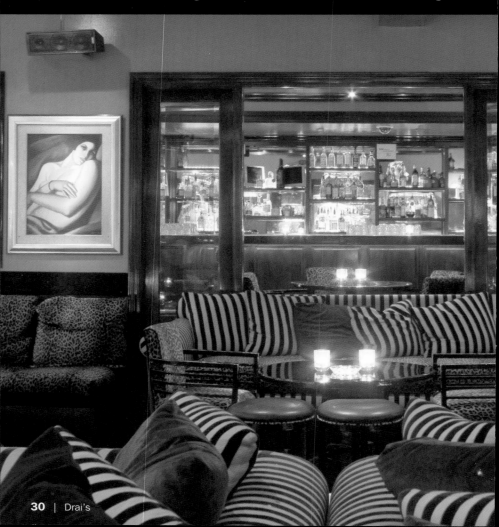

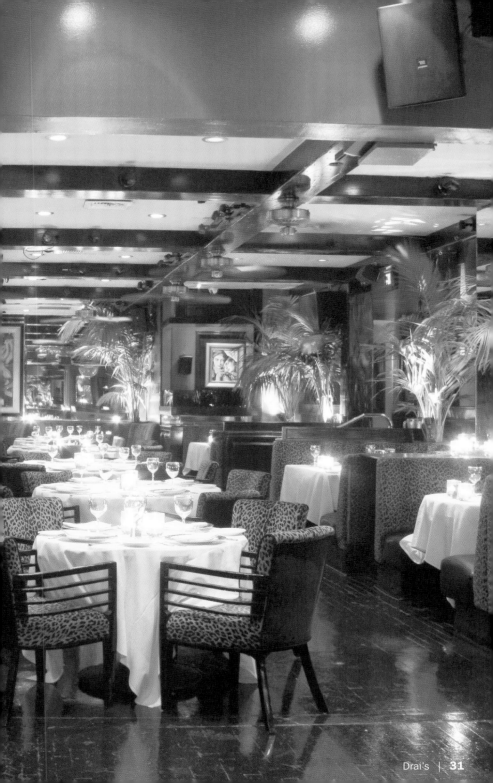

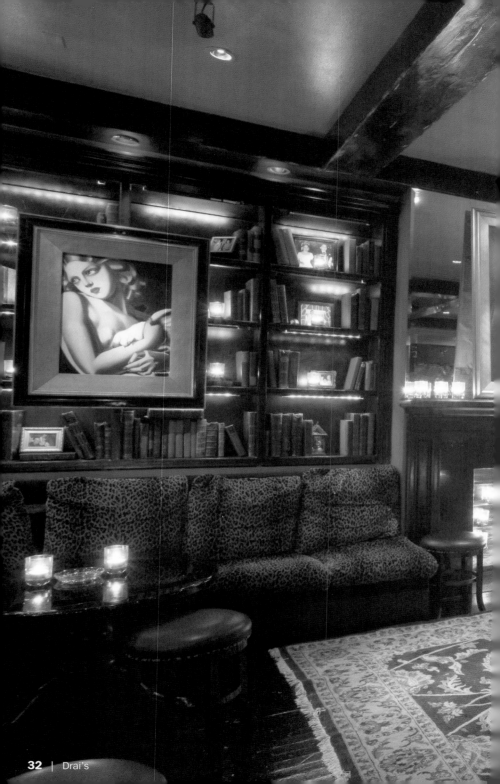

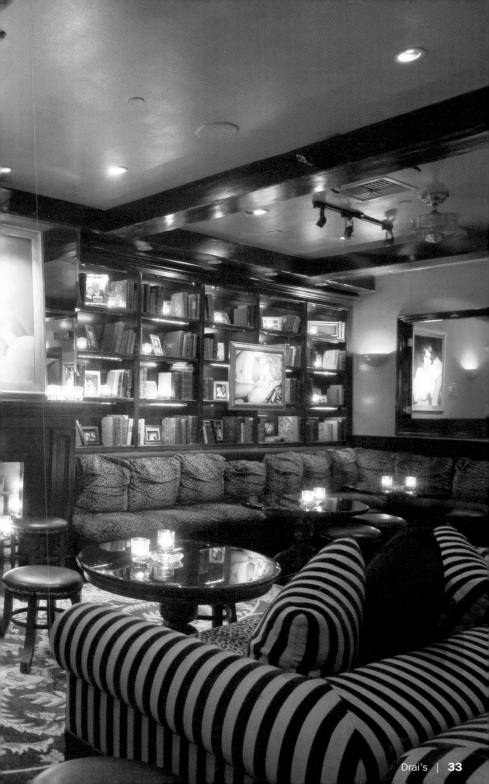

Fashion Outlet Las Vegas

Architect: MCG Architects

32100 S Las Vegas Boulevard | Primm, NV 89109 | Primm
Phone: +1 702 874 1400
www.fashionoutletlasvegas.com
Opening hours: Daily 10 am to 8 pm
Special features: Beautiful pilgrimage to this shopping outlet paradise in the desert

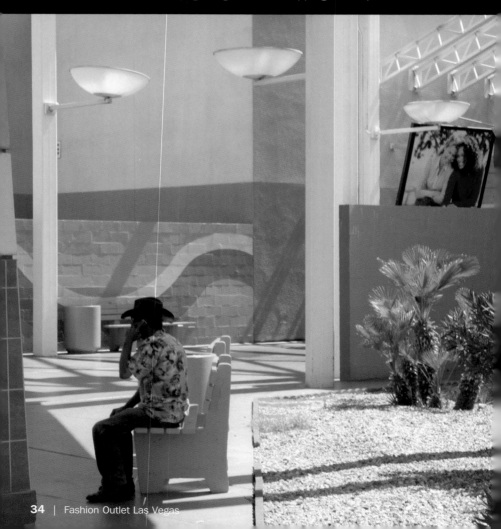

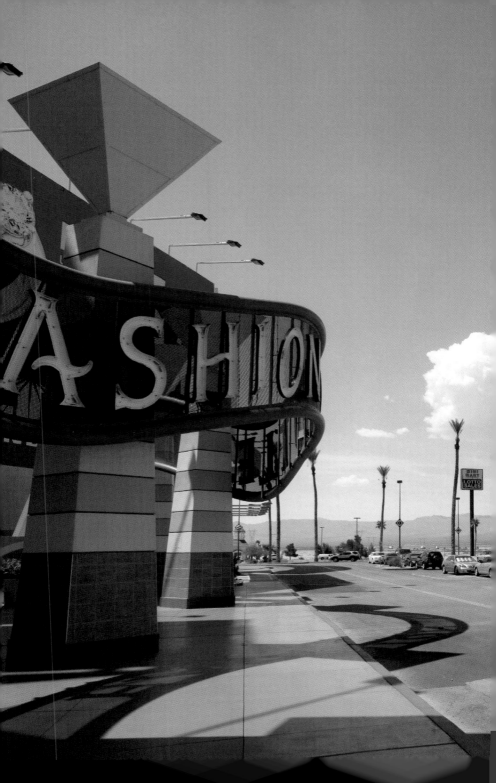

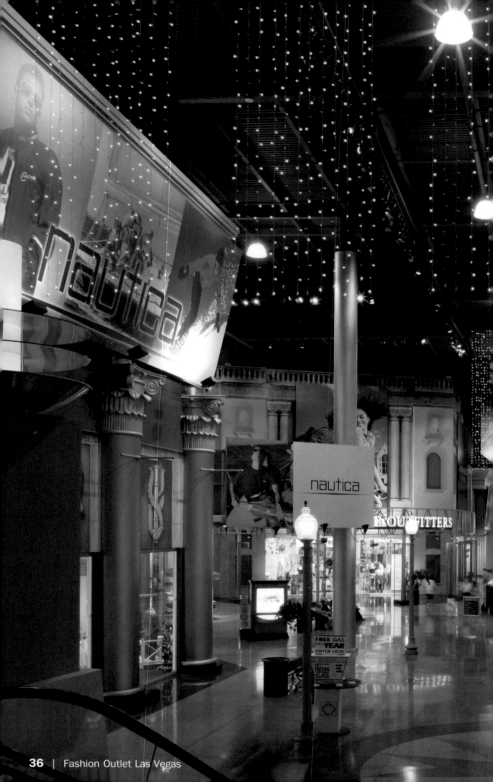

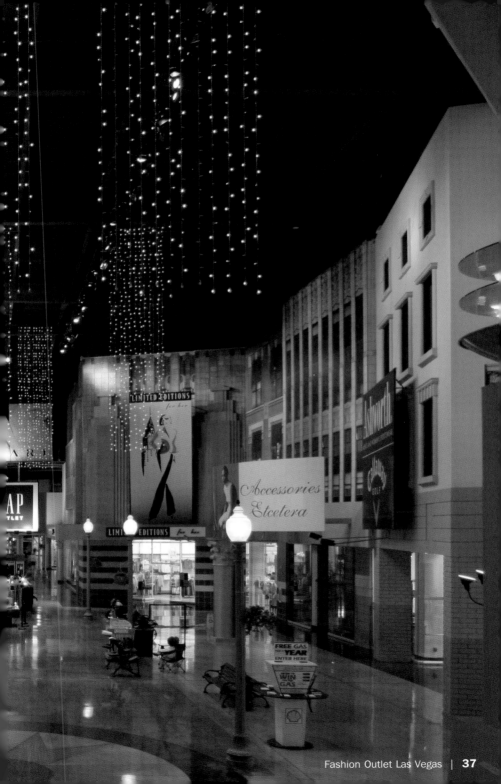

Four Seasons Hotel
Las Vegas

3960 S Las Vegas Boulevard | Las Vegas, NV 89119 | Four Seasons
Phone: +1 702 632 5000
www.fourseasons.com/lasvegas
Special features: Occupies top floors of Mandalay Bay with separate non-casino
lobby and elevators to provide an intimate, quiet experience

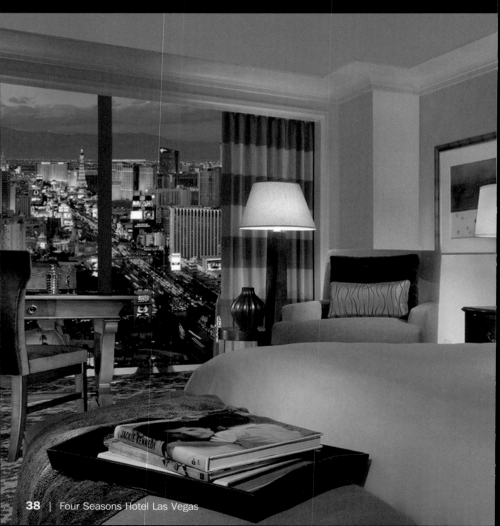

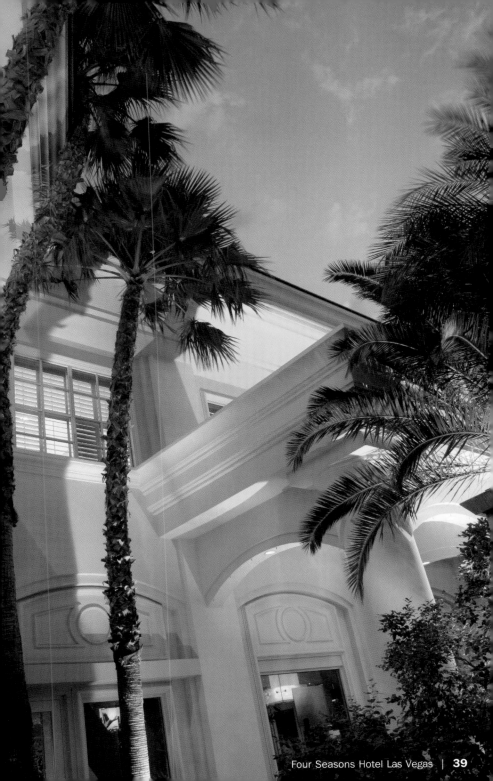

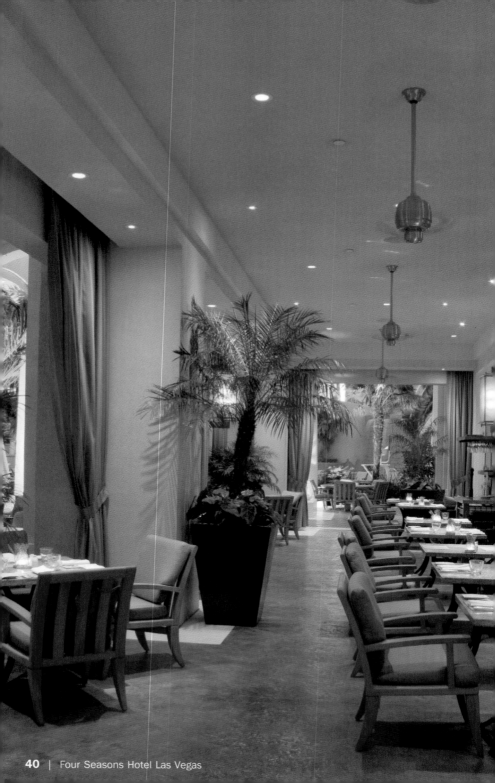

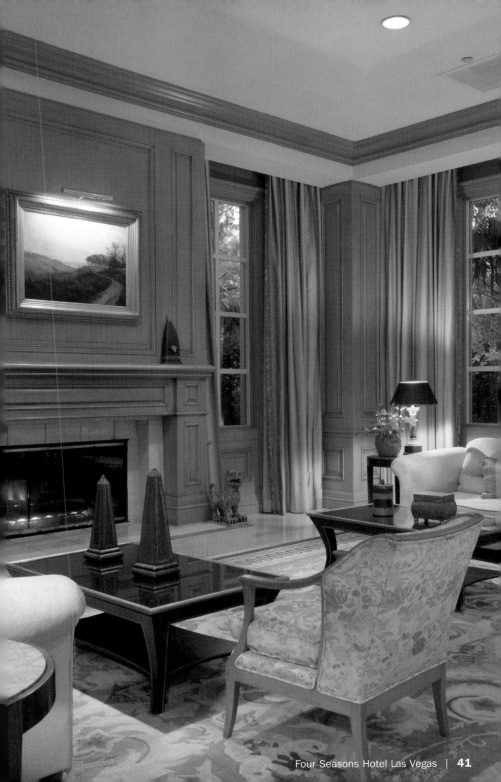

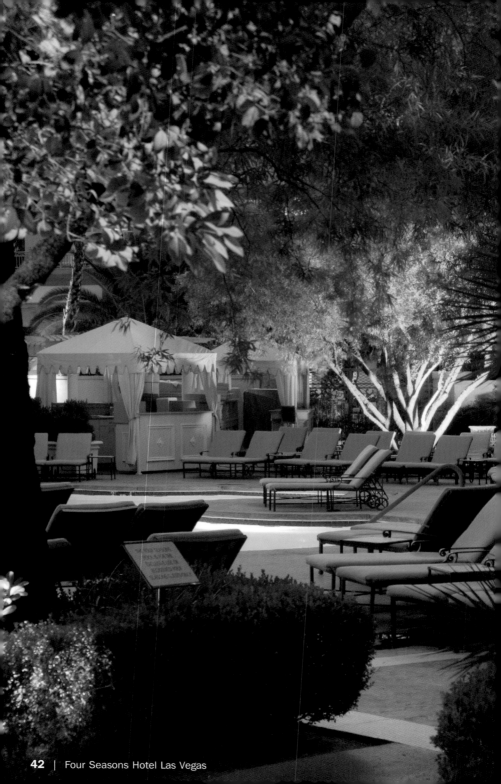

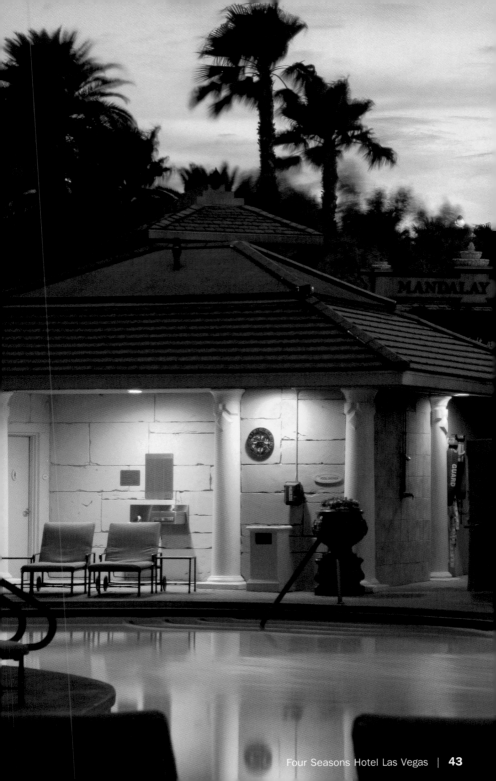

Hard Rock Hotel & Casino

4455 Paradise Road | Las Vegas, NV 89169 | Hard Rock Hotel
Phone: +1 702 693 5000
www.hardrockhotel.com
Special features: Hippest hotel filled with high-class rock'n'roll memorabilia and
tropical beach-inspired oasis with swim-up blackjack

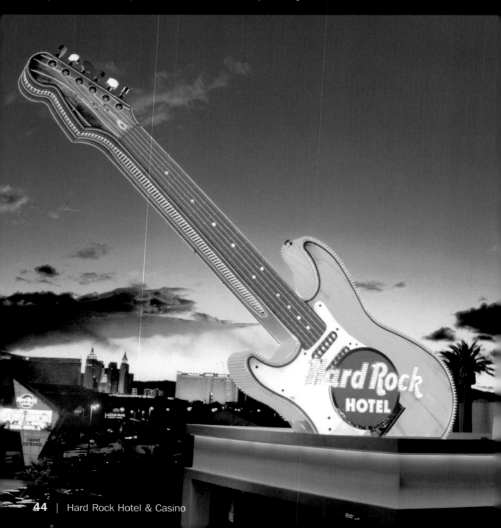

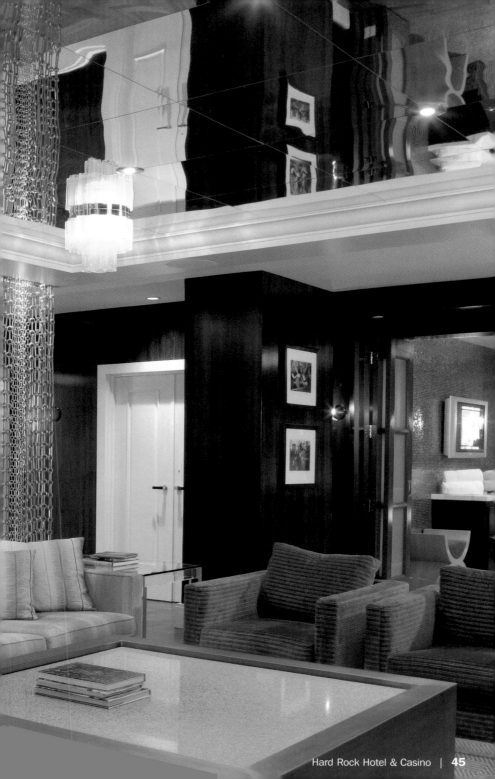

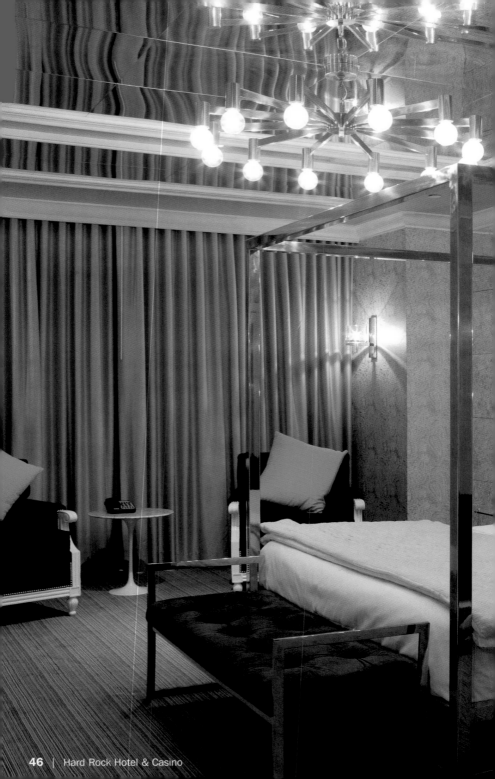

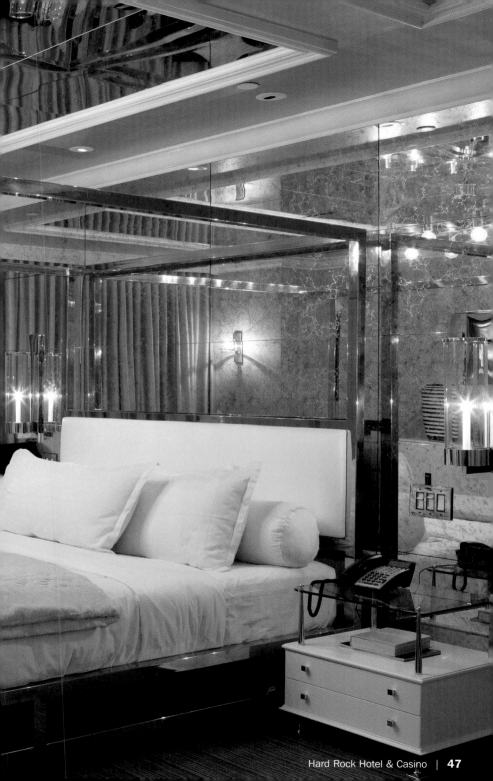

House of Blues

Design: Klai Juba & Teller Manok

3950 S Las Vegas Boulevard | Las Vegas, NV 89119 | Mandalay Bay
Phone: +1 702 632 7600
www.hob.com
Opening hours: Sun–Thu 7:30 pm to midnight, Fri–Sat 7:30 pm to 1 am
Special features: Eclectic Southern-inspired decor celebrating blues music with folk art and with nightly live music shows

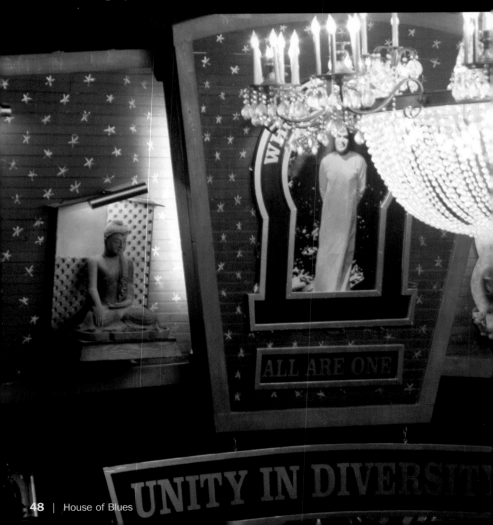

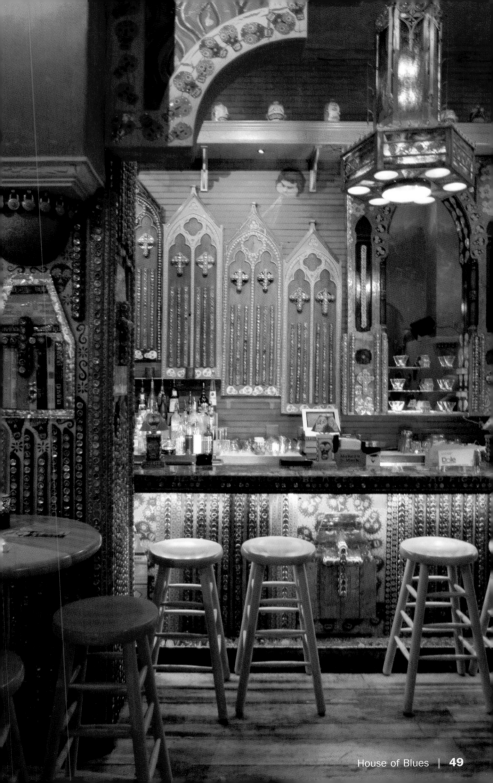

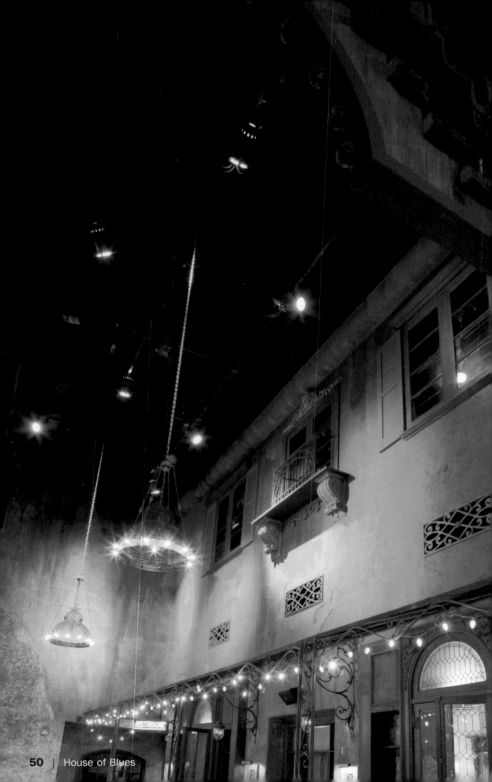

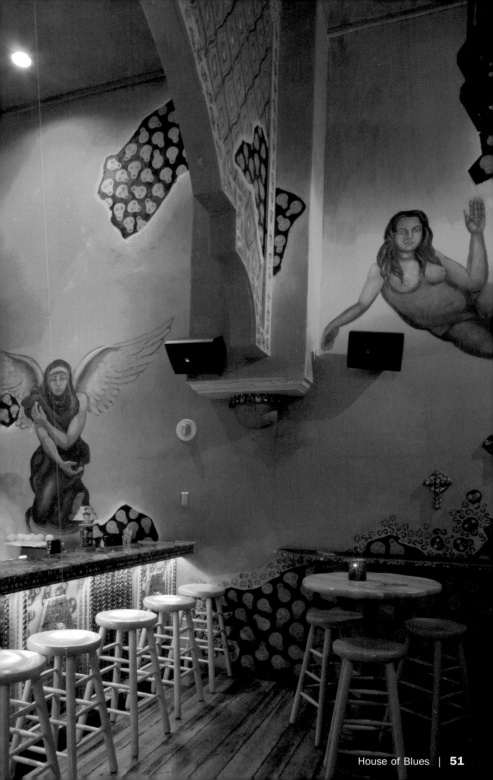

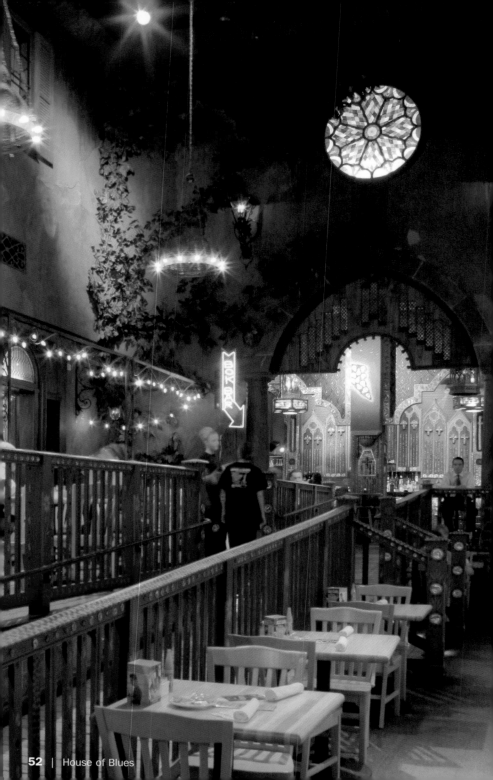

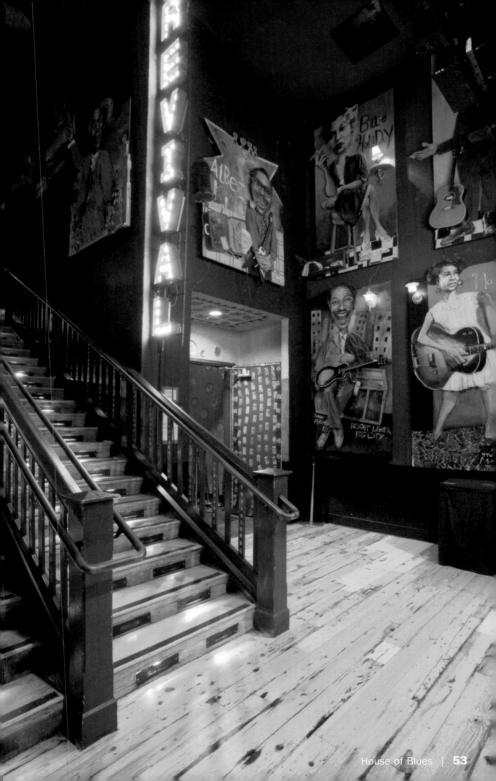

Ice

Design: Tom Schooner

200 E Harmon Avenue | Las Vegas, NV 89109
Phone: +1 702 699 9888
www.icelasvegas.com
Opening hours: Daily 11 pm to 4 am
Special features: Trendy New-York-Club look with Brazilian-walnut dance space, with
separate lounges with fur-lined walls and minimalist ultra-chic furnishings

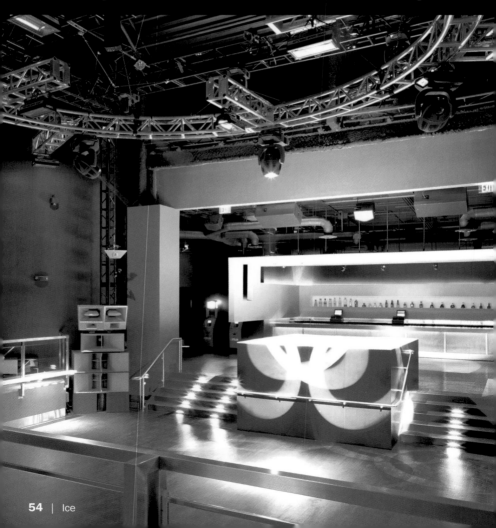

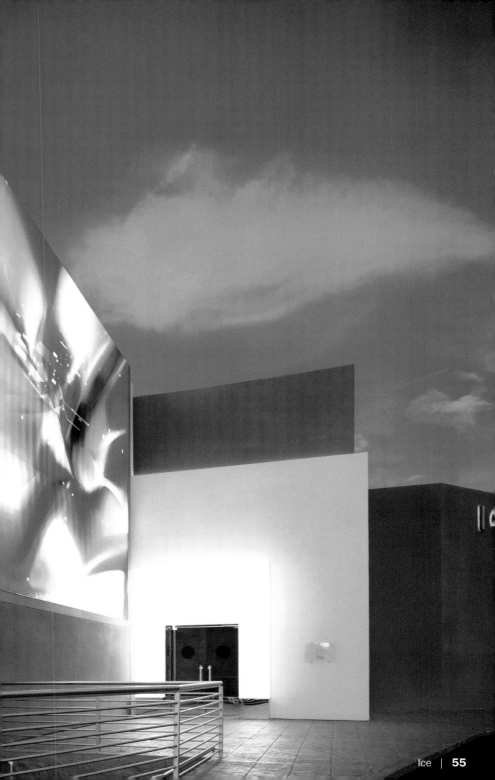

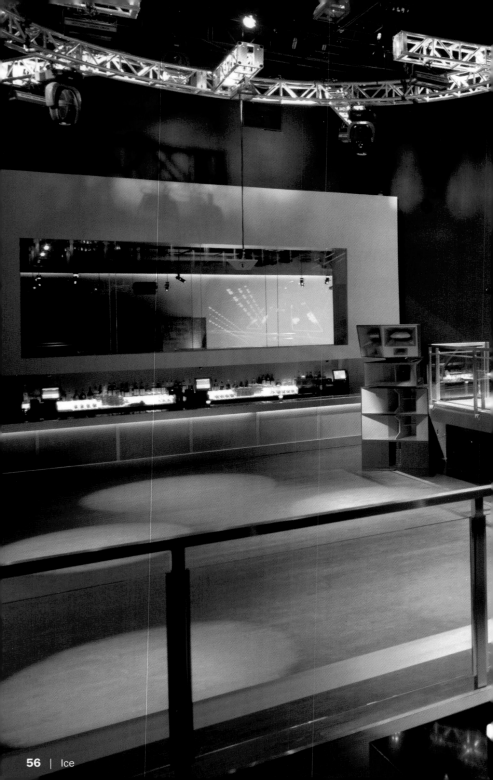

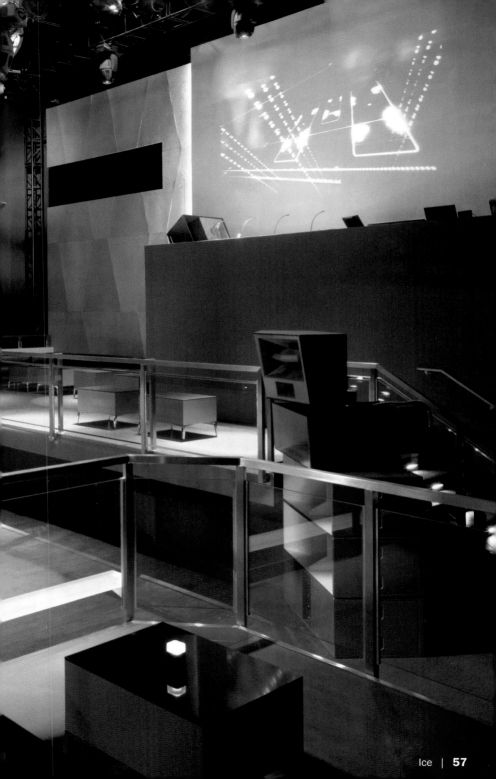

Ivan Kane's Forty Deuce

Design: Frederick Sutherland

3930 S Las Vegas Boulevard 200B | Las Vegas, NV 89119 | Mandalay Bay
Phone: +1 702 632 9442
www.fortydeuce.com
Opening hours: Thu–Mon 10:30 pm 'til dawn
Special features: Nightclub with a smoky, seductive vibe with live burlesque shows
accompanied by a three-piece band

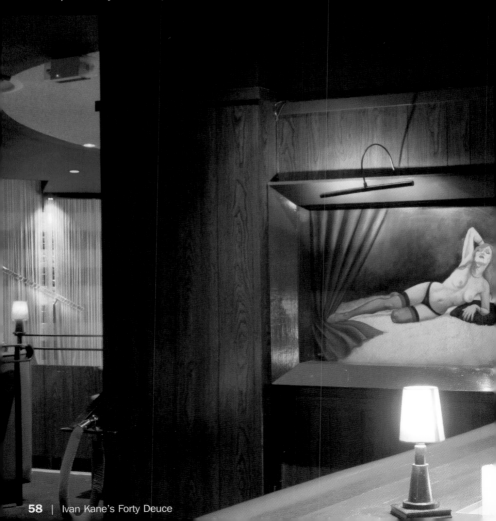

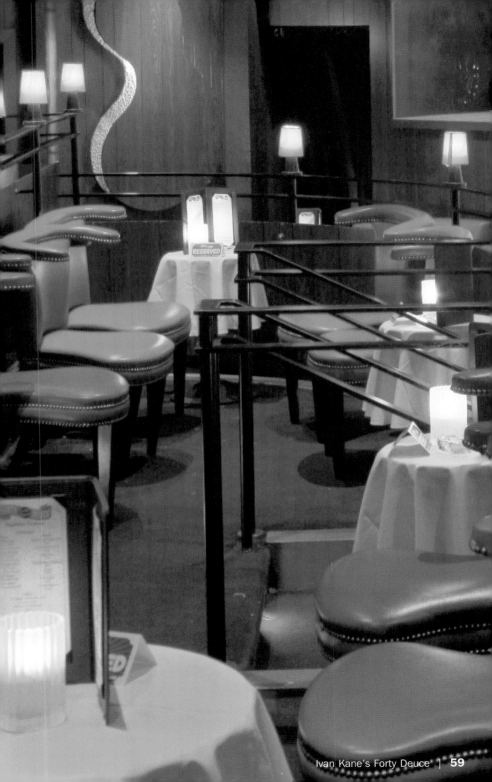

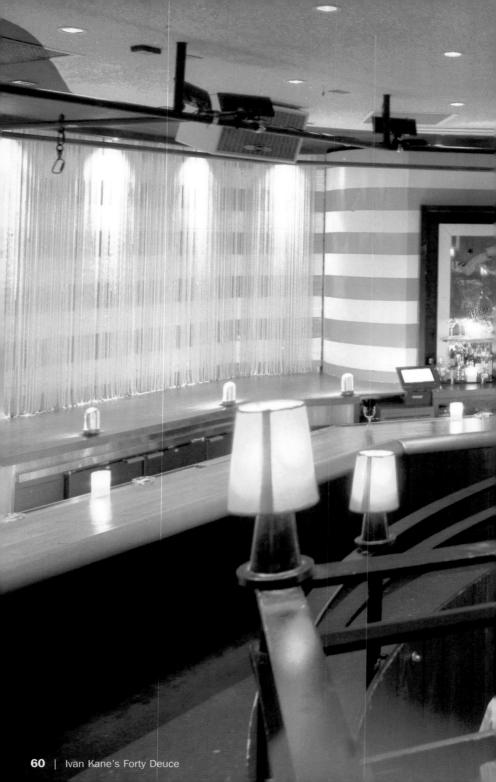

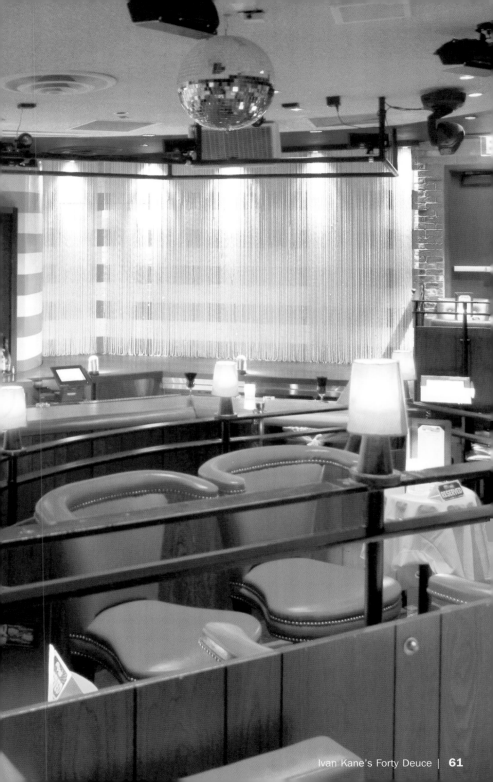

Las Vegas Premium Outlets

875 S Grand Central Parkway | Las Vegas, NV 89106 | Outlet Shopping
Phone: +1 702 474 7500
www.premiumoutlets.com
Opening hours: Sun 10 am to 8 pm, Mon–Sat 10 am to 9 pm
Special features: Outdoor outlet for high-end bargain hunters with over 120 shops

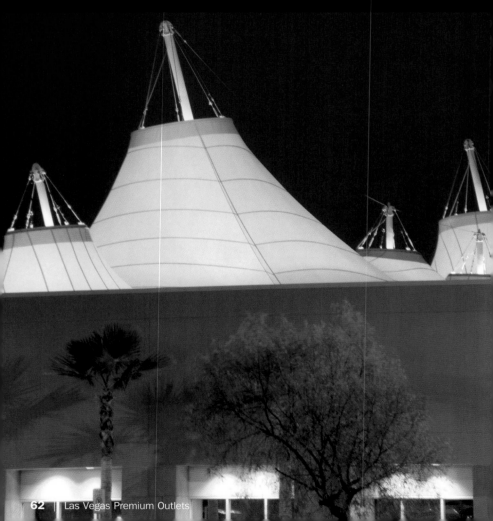

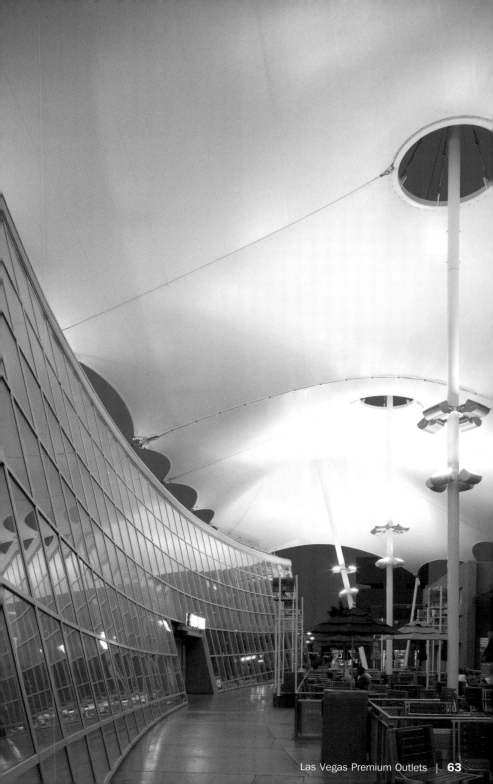

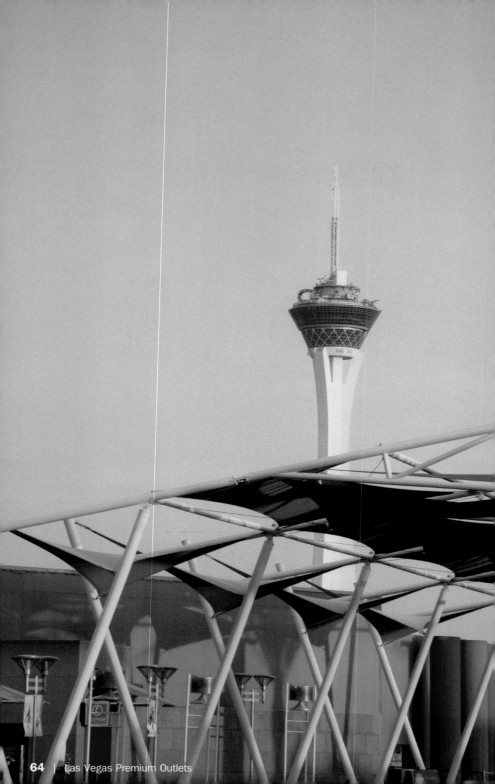

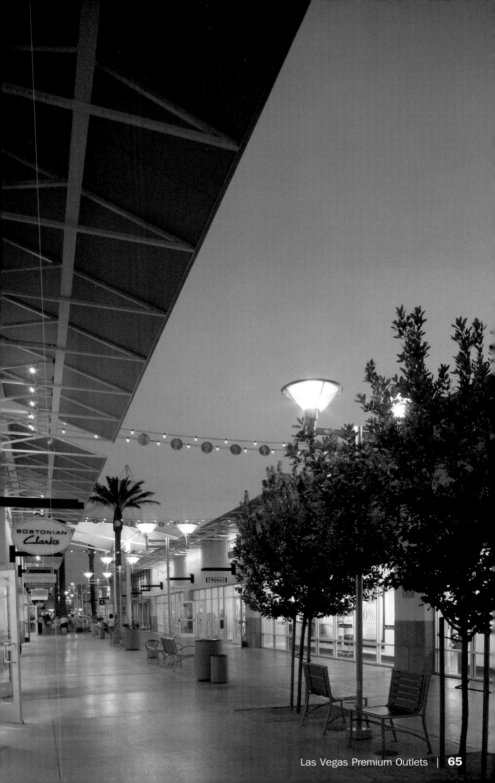

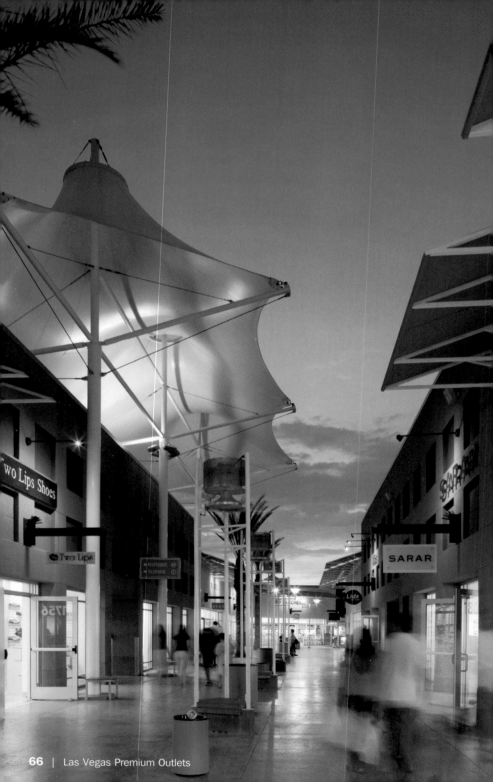

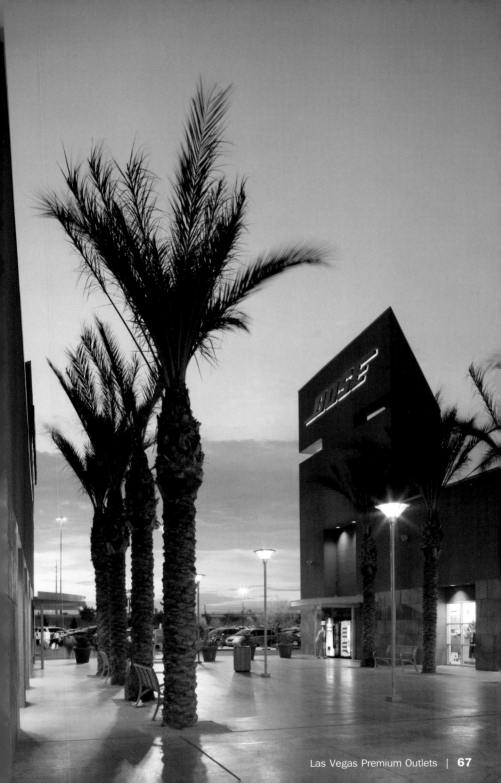

Little Buddha

Design: Rockwell Group

4321 W Flamingo Road | Las Vegas, NV 89103 | Palms
Phone: +1 702 942 7778
www.littlebuddhalasvegas.com
Opening hours: Daily 5:30 pm to 11 pm
Special features: Asian-inspired restaurant/lounge with feng shui interior design,
poolside dining, and an impressive lobby with floor-to-ceiling Buddha statues

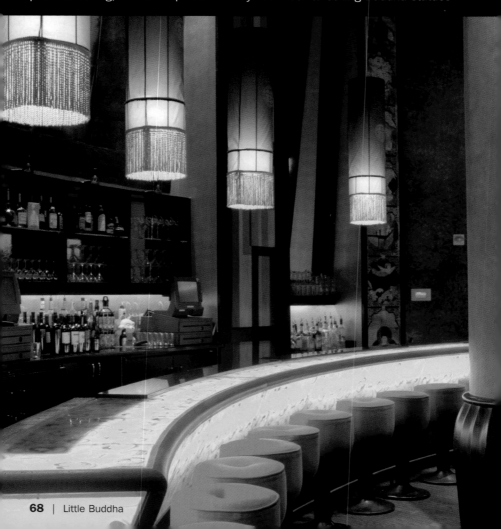

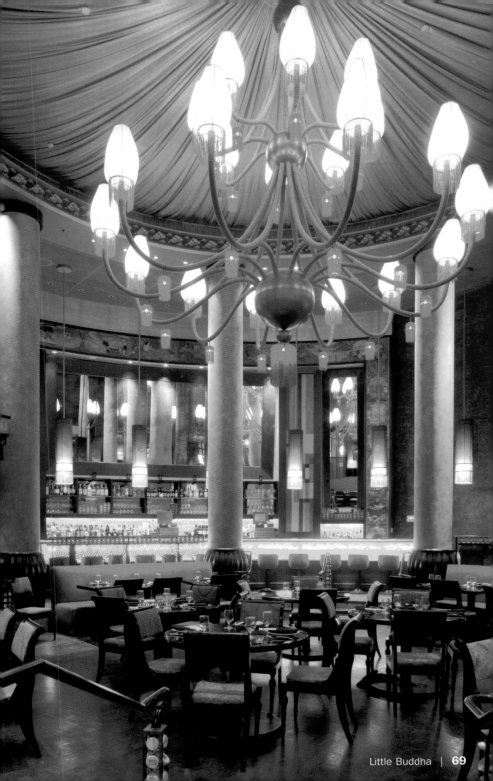

Opening hours: Daily 6 am to 10 pm
Cool factor: Ride to Canyon/Nighttime ride into Vegas

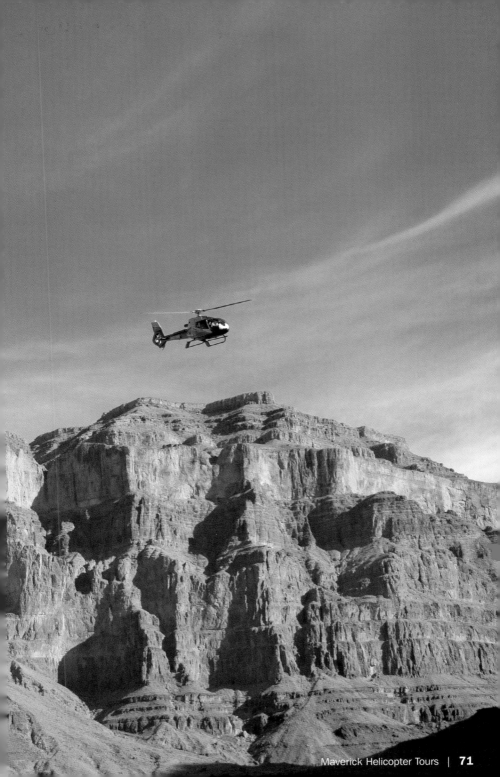

Mix

Design: Patrick Jouin

3950 S Las Vegas Boulevard | Las Vegas, NV 89119 | Mandalay Bay
Phone: +1 702 632 9500
www.mandalaybay.com
Opening hours: Daily 5:30 pm to 10:30 pm
Special features: Culinary art served under magnificent 24-ft chandelier of 15,000 hand-blown spheres and spectacular windows offer astonding views over Vegas

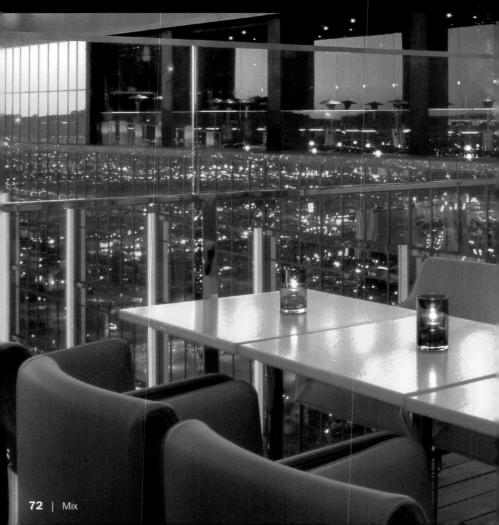

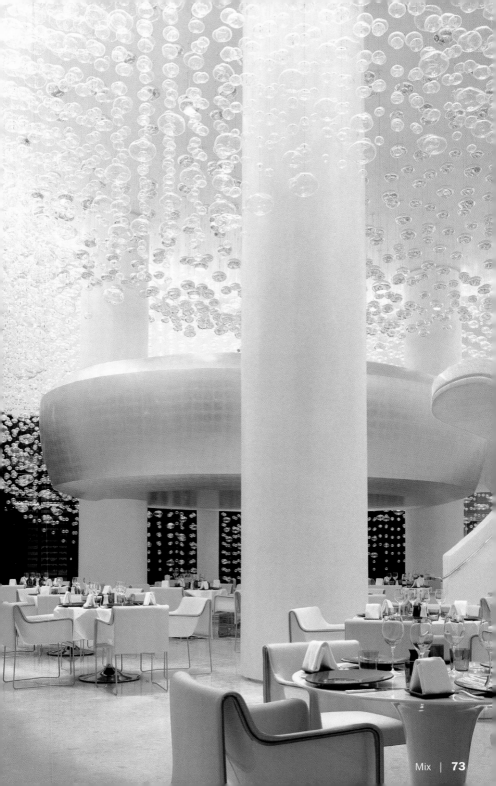

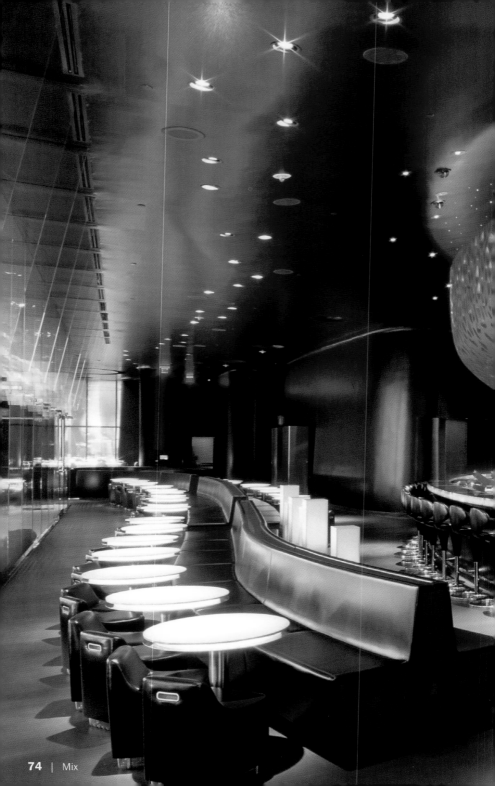

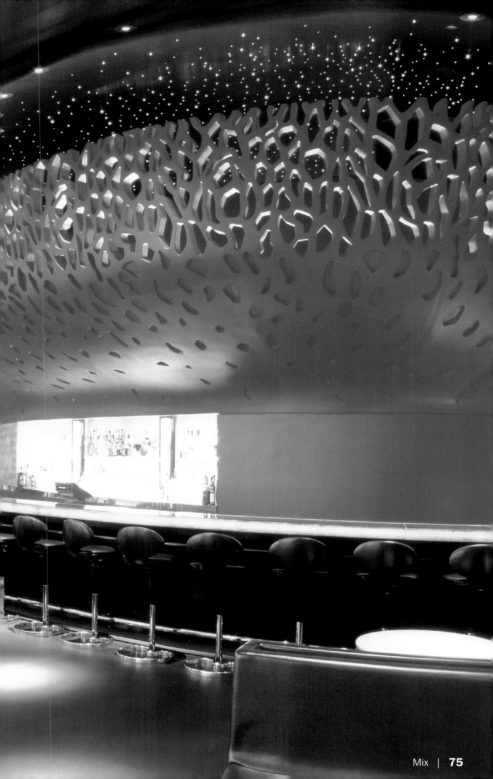

Montelago Village

Design: Intrawest

Montelago Village Resort, 30 Strada di Villaggio | Henderson, NV 89012 | Lake Las Vegas
Phone: +1 702 564 4700
www.montelagovillage.com
Special features: Lakeside lodging off the Vegas strip with shopping, fine dining,
award-winning golf course and many other outdoor activities

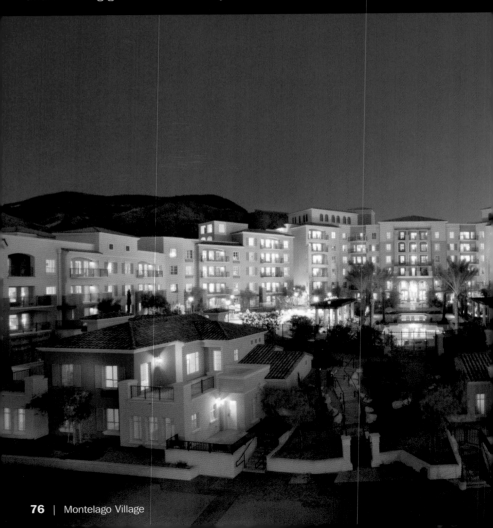

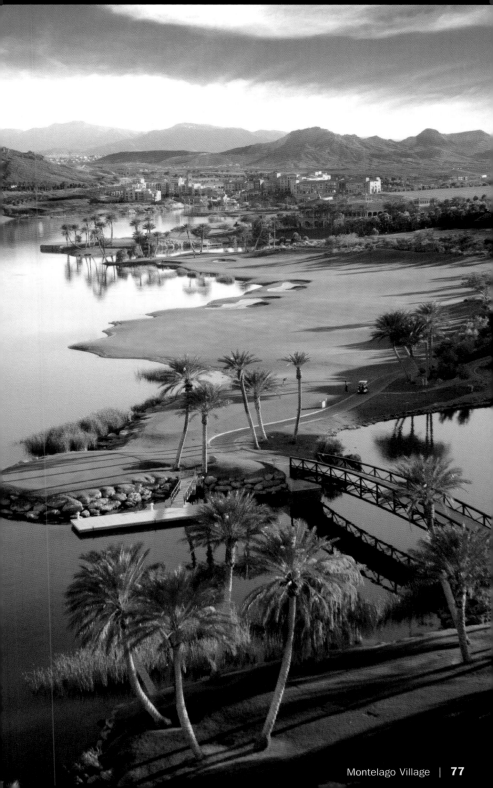

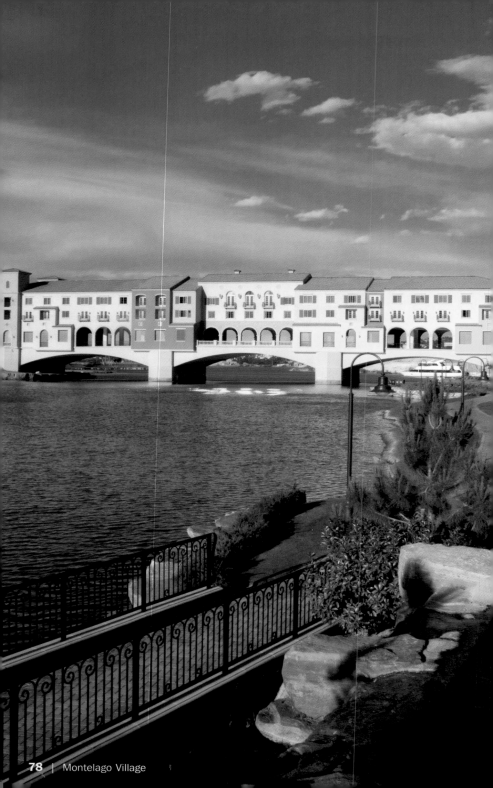

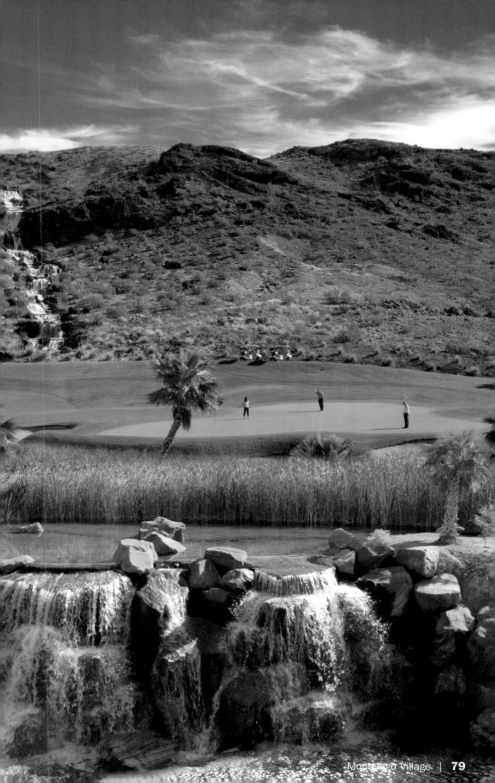

Palms Spa & Pool

4321 W Flamingo Road | Las Vegas, NV 89103 | Palms
Phone: +1 866 942 7770
www.palms.com
Opening hours: Spa daily 6 am to 8 pm, pool daily 9 am to 5 pm
Special features: Pool area transforms into hip outdoor party complete with concert stage, elevated dance floor, and lavender-shaded pool with sandy beach

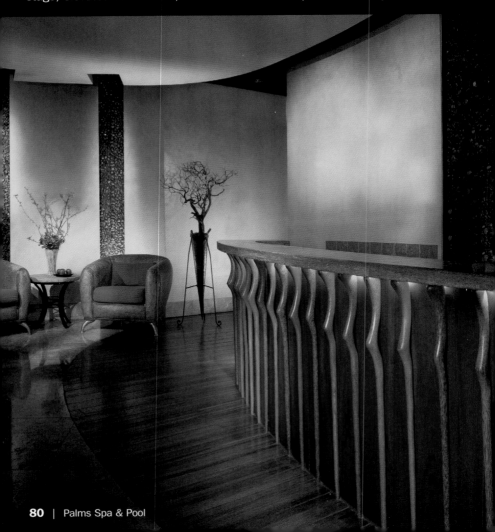

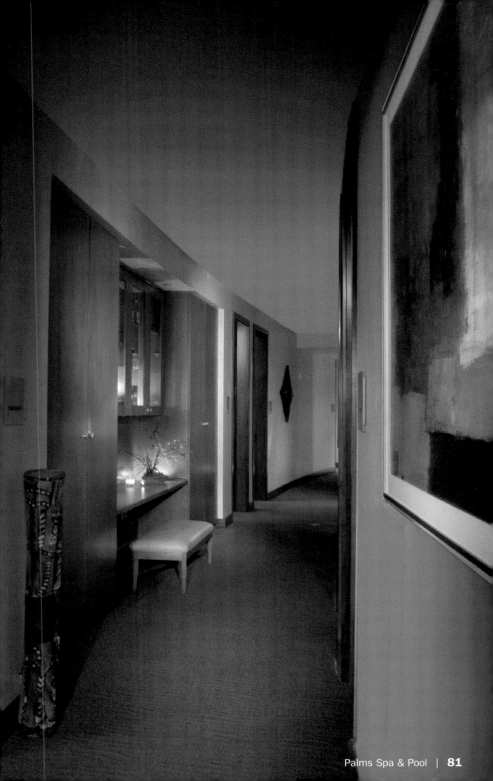

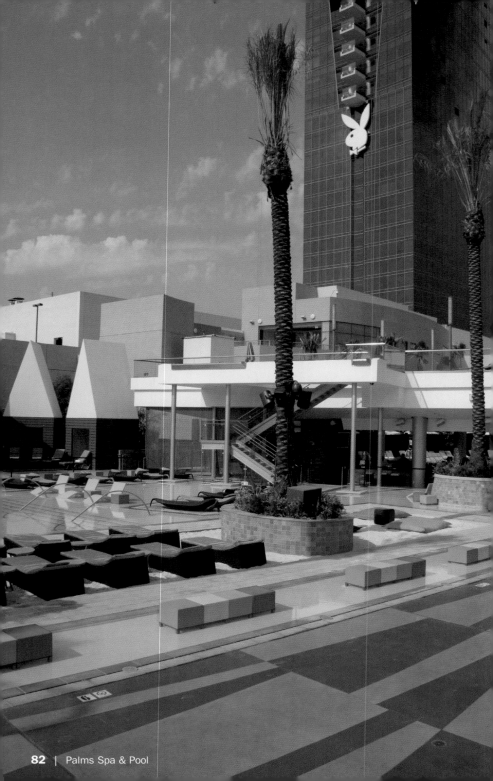

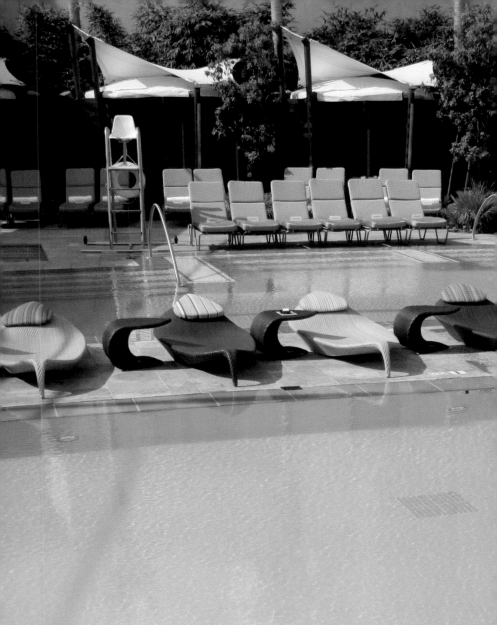

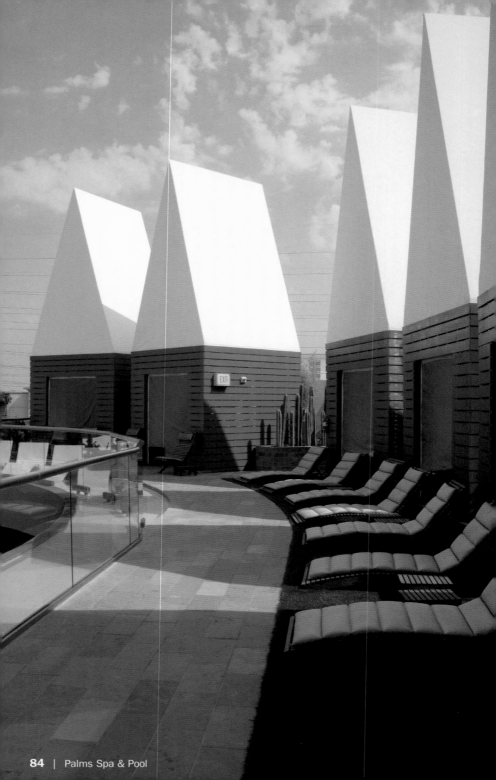

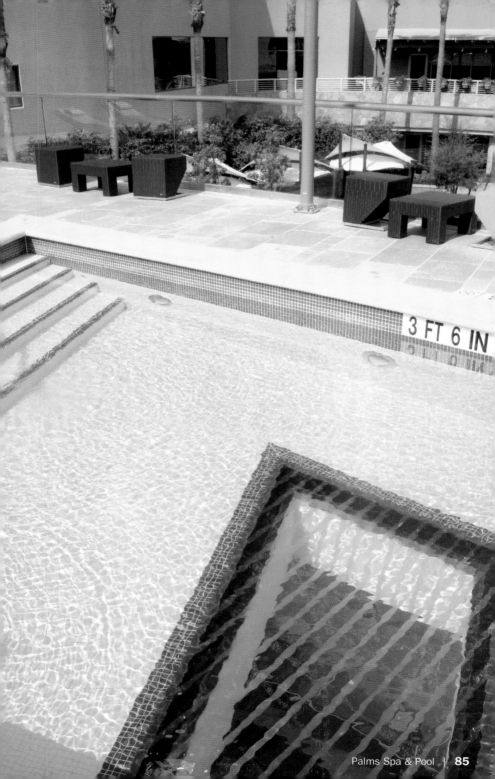

3 FT 6 IN

Palms Themed Suites

4321 W Flamingo Road | Las Vegas, NV 89103 | Palms
Phone: +1 866 942 7770
www.palms.com
Special features: Extravagant themed party suites, some with a swimming pool, a
basketball court, Playboy branded private mecca, recording studio, or screening
room

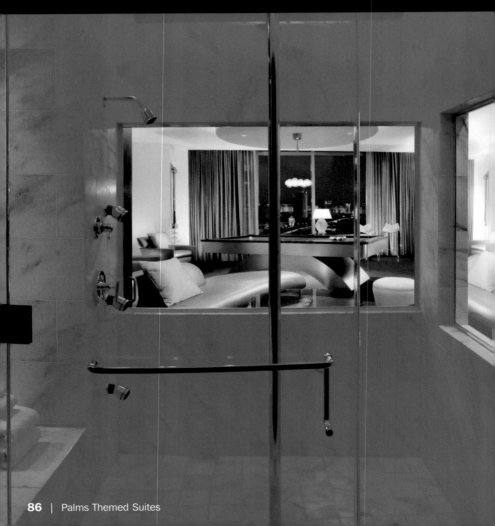

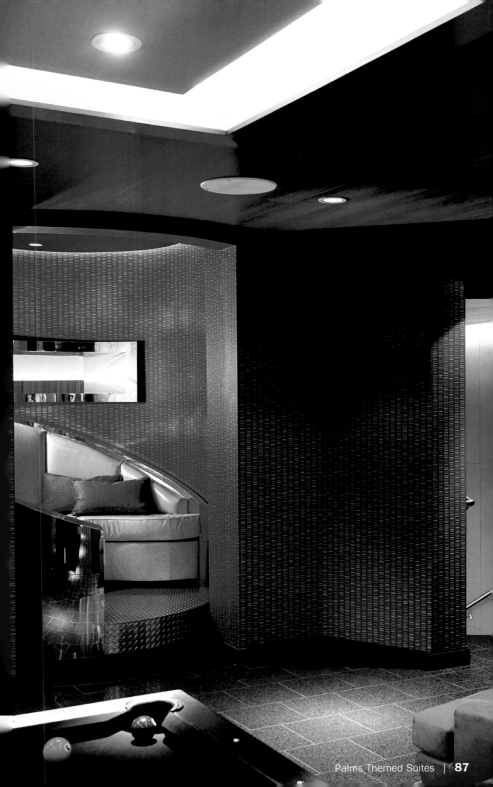

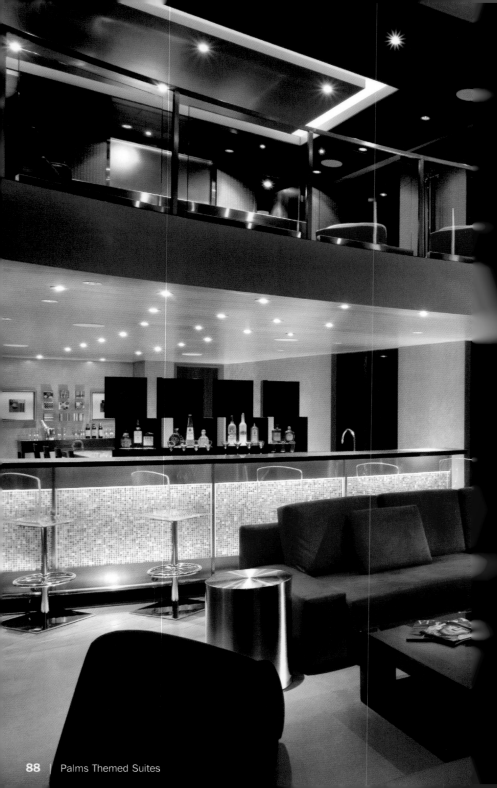

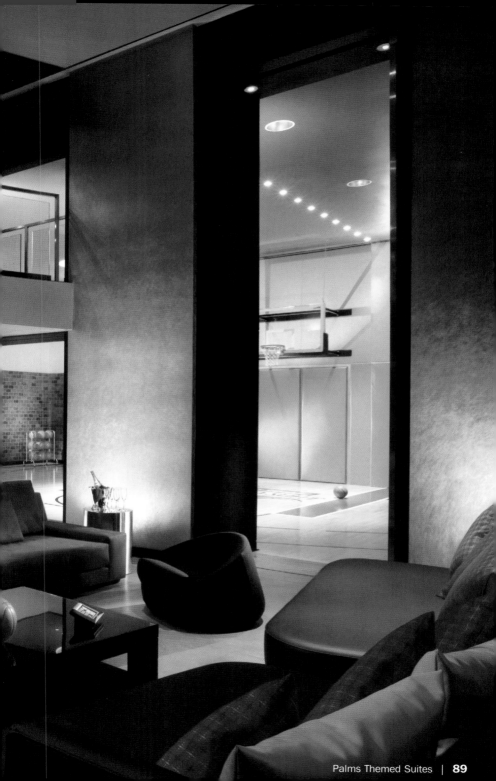

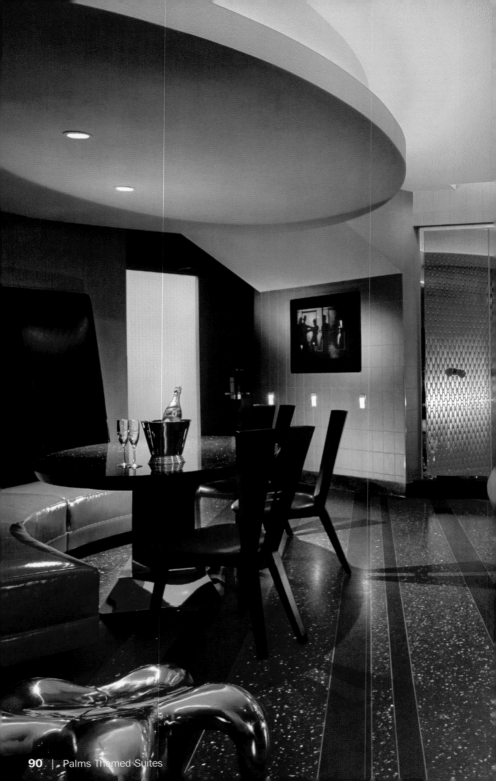

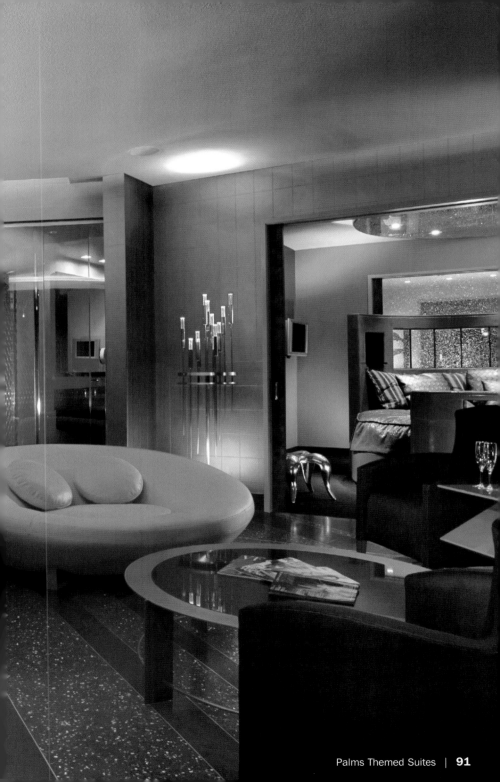

Red Rock Canyon

17 miles west of the Las Vegas Strip
www.redrockcanyonlv.org
Opening hours: 13-miles scenic drive and red rock overlook daily 6 am to 8 pm,
visitor center 8 am to 4:30 pm
Special features: Most amazing scenic place to visit with striking red colored sandstone formations layered with gray limestone

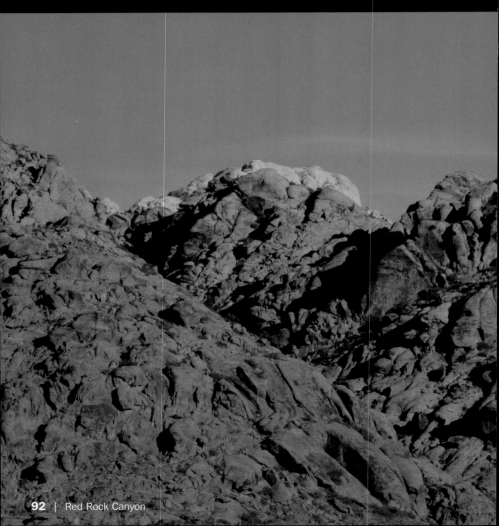

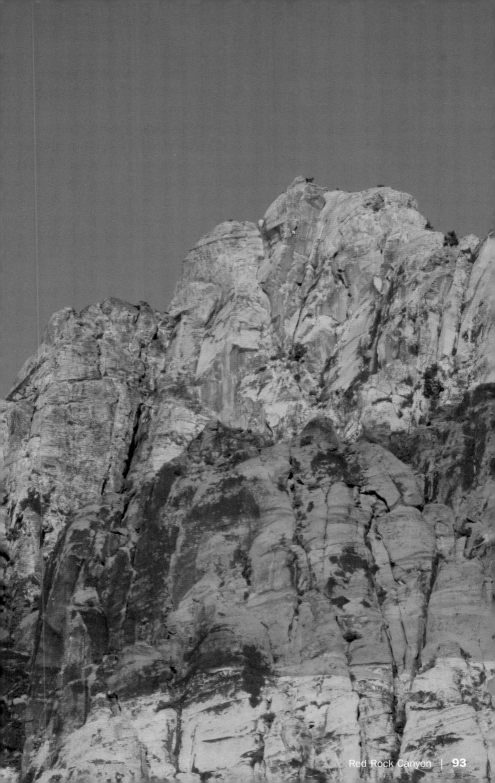

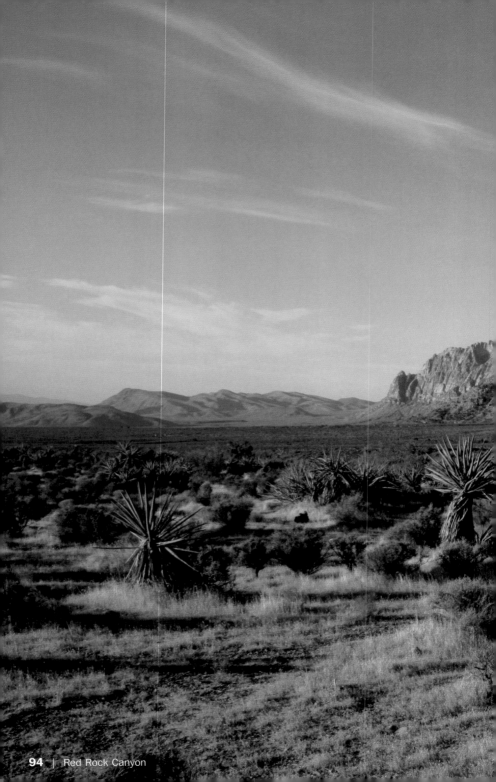

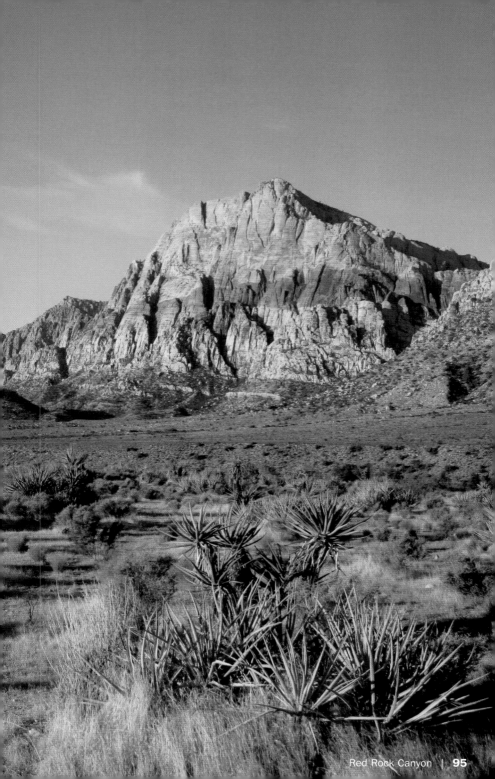

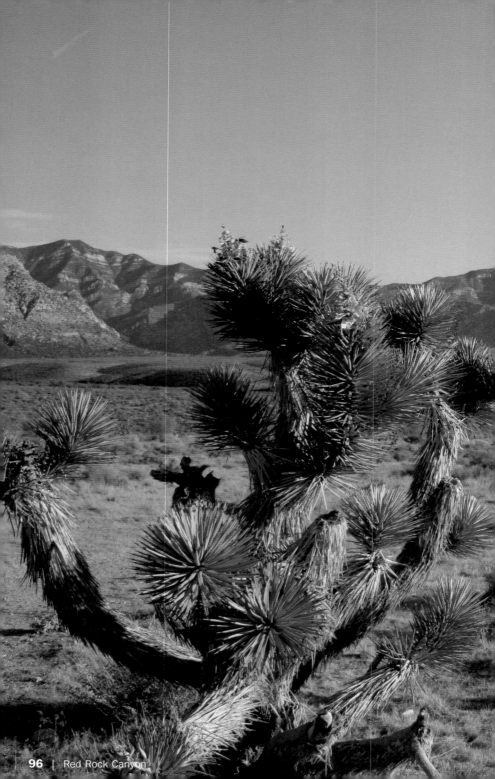

96 | Red Rock Canyon

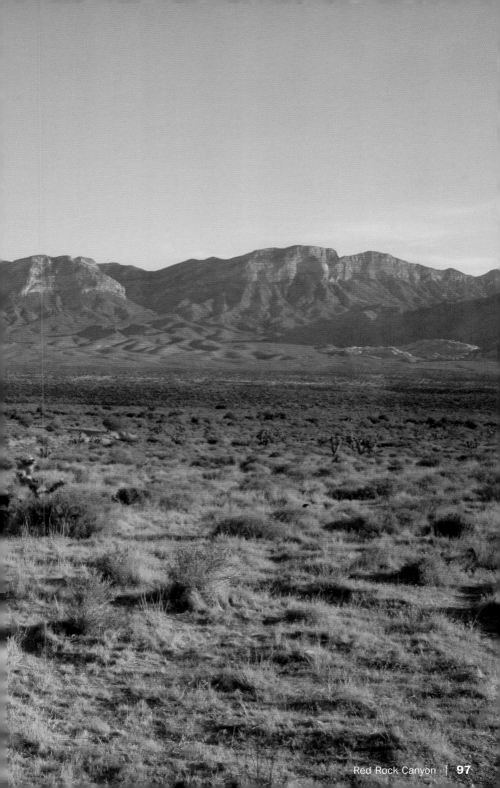

SKYLOFTS

Design: Tony Chi

3799 S Las Vegas Boulevard | Las Vegas, NV 89109 | MGM
Phone: +1 877 646 5638
www.skyloftsmgmgrand.com
Special features: Luxury two-story units 30 floors above the Las Vegas skyline with
24-ft windows and sophisticated modern furnishings as well as 24-hour butler
service

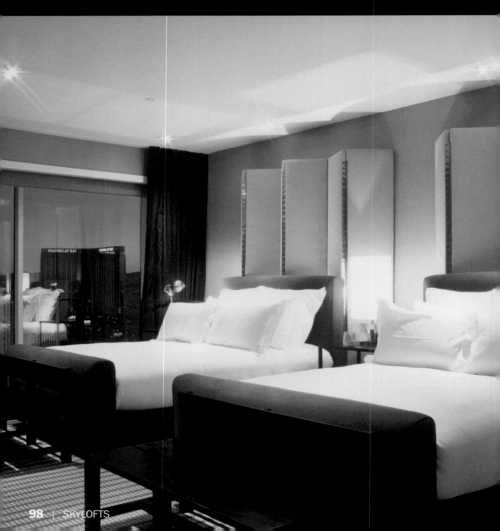

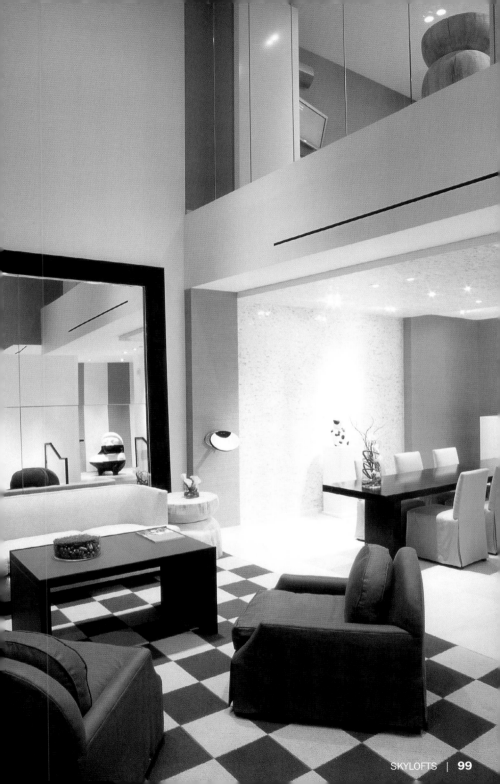

Skywalk

Architect: MRJ Architects
Engineering: Lochsa Engineering
Construction: LLC and APCO Construction

Grand Canyon West, Diamond Bar Road | Skywalk
Phone: +1 877 716 9378
www.destinationgrandcanyon.com/skywalk.html
Special features: Walkway attached to the side of the Grand Canyon about
4,000 ft above the Colorado River with glass bottom and sides

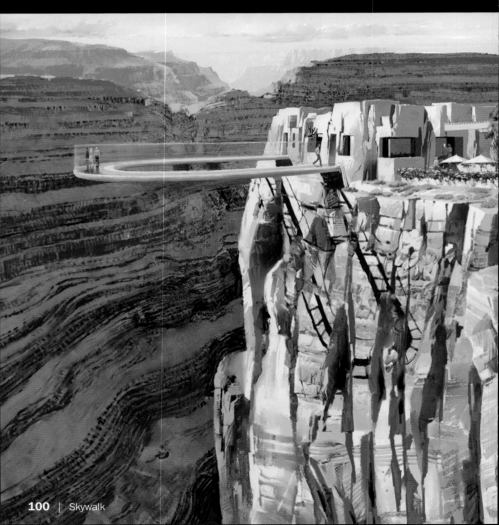

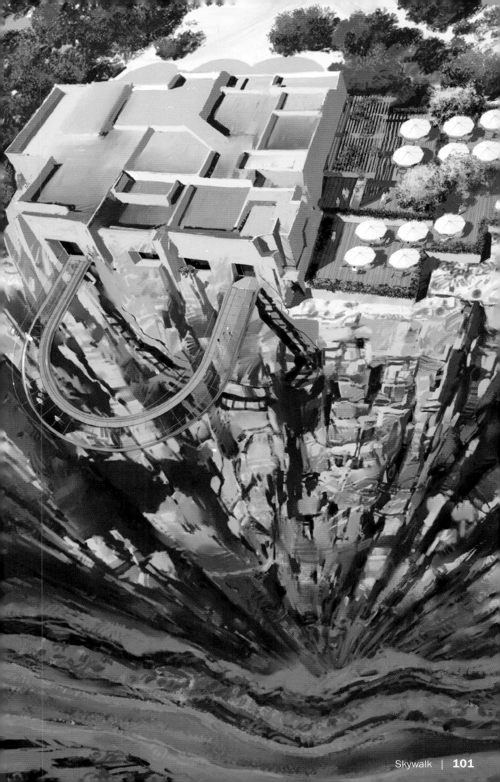

Stack

Design: GRAFT

3400 S Las Vegas Boulevard | Las Vegas, NV 89109 | Mirage
Phone: +1 866 339 4566
www.stacklasvegas.com
Opening hours: Daily 5 pm to 11:45 pm
Special features: Expansive dining area with layered mahogany walls, with sophisti-
cated dishes as well as fun "kids menus" tailored for adults

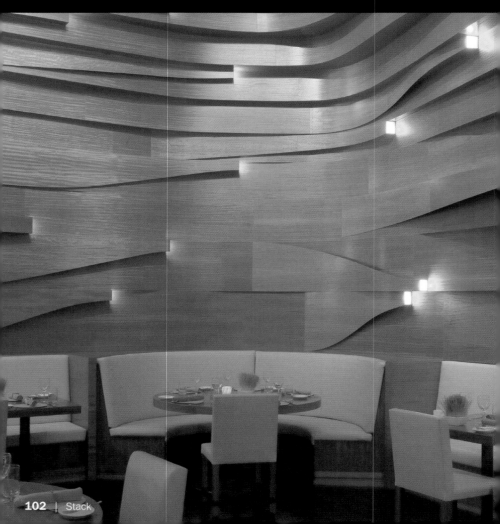

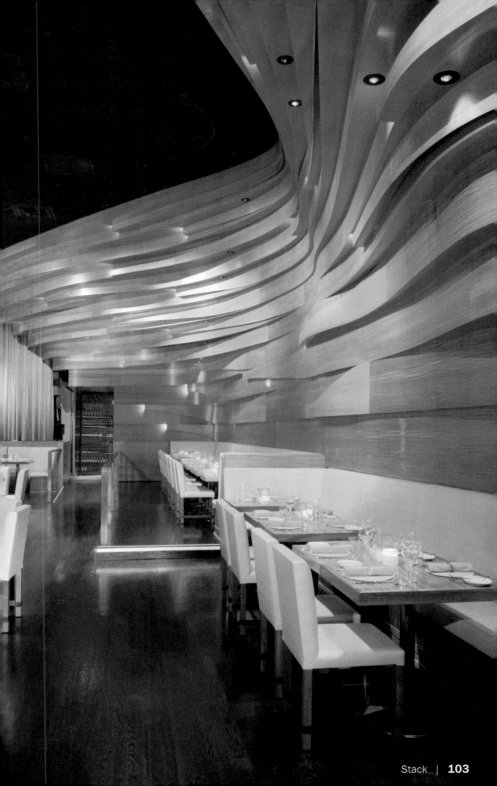

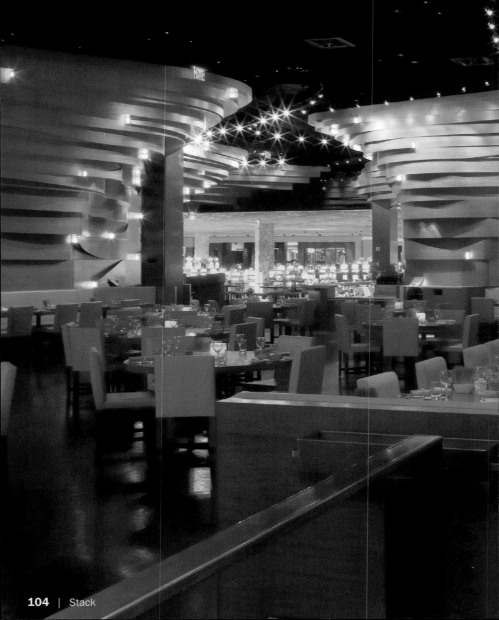

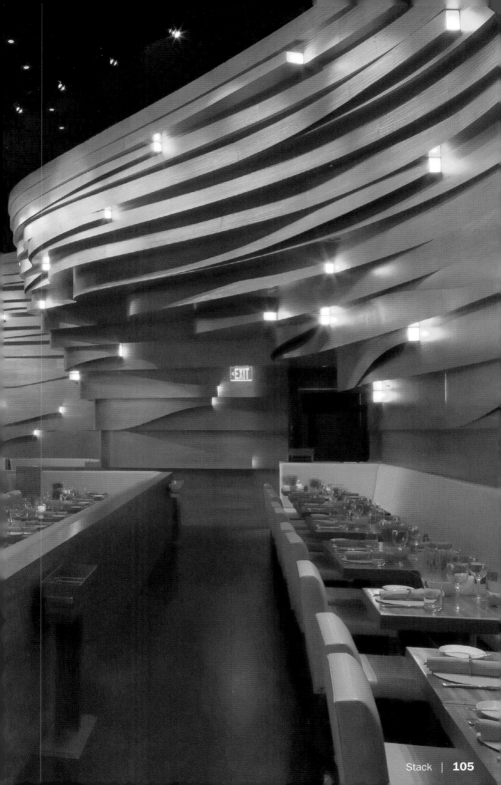

Tao Asian Bistro

Design: Thomas Schoos, Studio Gaia

3377 S Las Vegas Boulevard | Las Vegas, NV 89109 | Venetian
Phone: +1 702 388 8338
www.taolasvegas.com
Opening hours: Restaurant: Sun–Thu 5 pm to midnight, Fri–Sat 5 pm to 1 am;
lounge daily 5 pm to 5 am; nightclub Thu–Sat 10 pm to 5 am
Special features: 44,000-sq-ft ultra-lounge, nightclub, and restaurant with 20-ft-tall
hand-carved Buddha above infinity pool with Japanese carp in main dining room

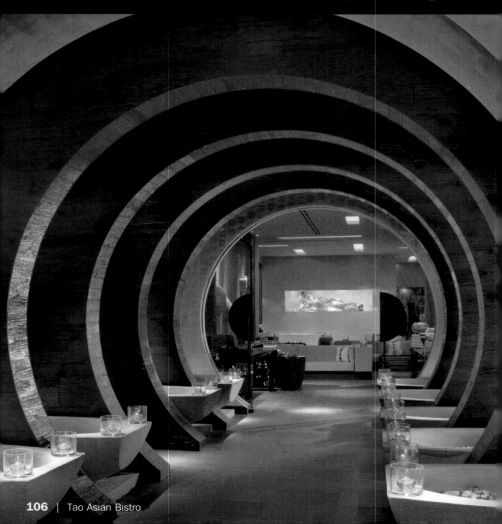

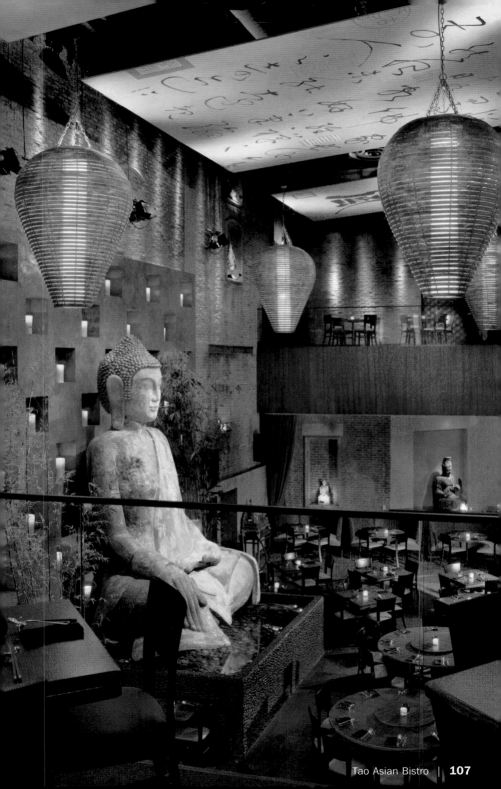

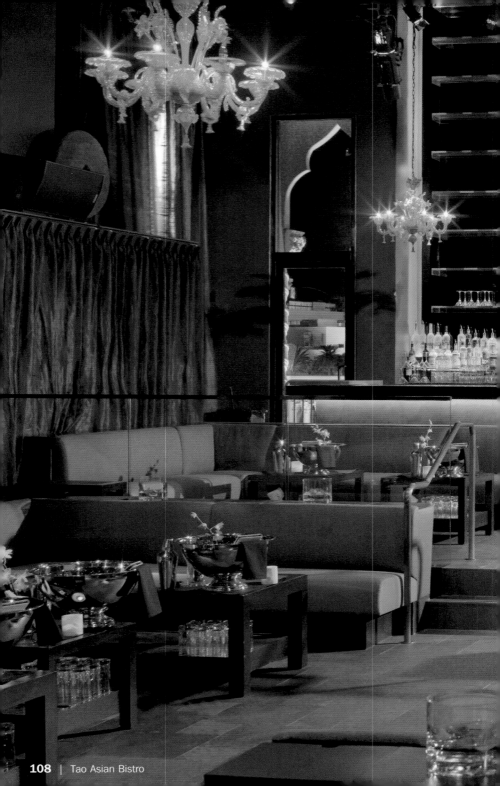

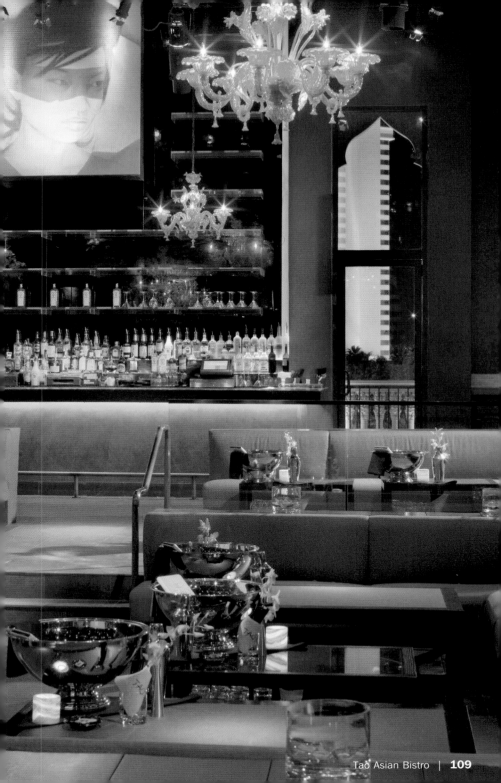

The Fashion Show

Architect: Altoon + Porter, L.A.
Concept Designers: Laurin B. Askew, MONK of Baltimore,
Richard Orne of Orne + Assoc., Inc., L.A.

3200 S Las Vegas Boulevard | Las Vegas, NV 89109
Phone: +1 702 369 0704
www.thefashionshow.com
Opening hours: Mon–Fri 10 am to 9 pm, Sat 10 am to 8 pm, Sun 11 am to 7 pm
Special features: One of the largest shopping centers in the nation with over 250
extraordinary shops and restaurants, including fashion shows on the weekends

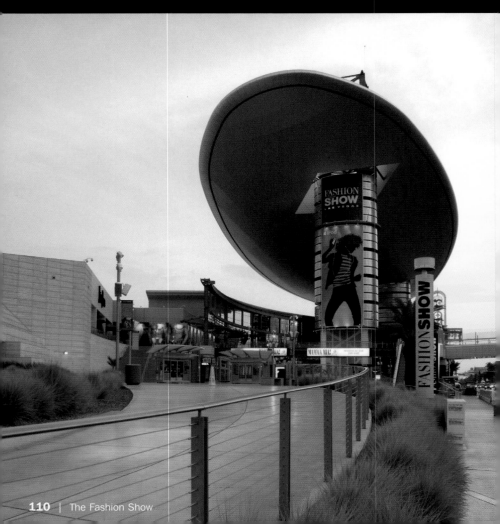

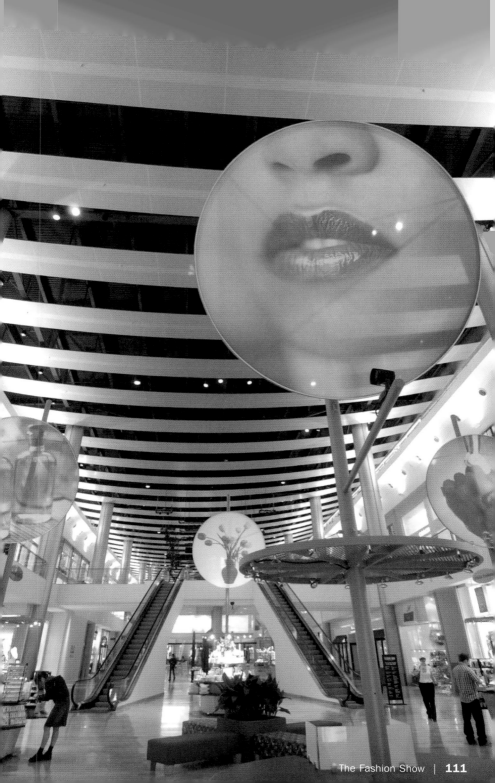

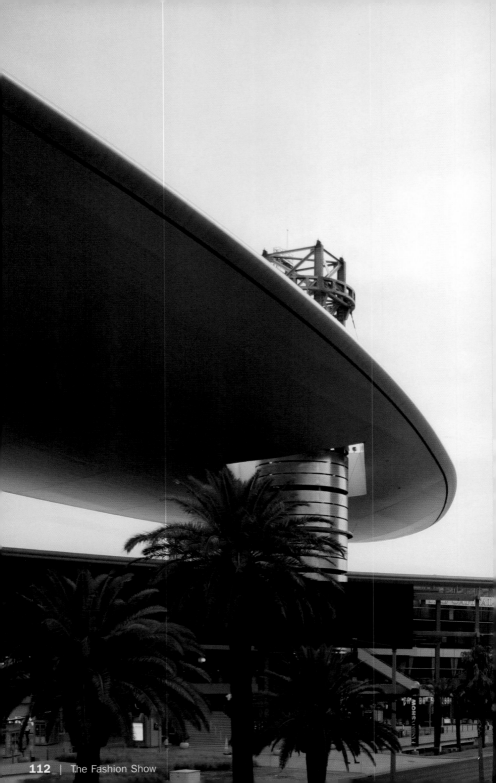

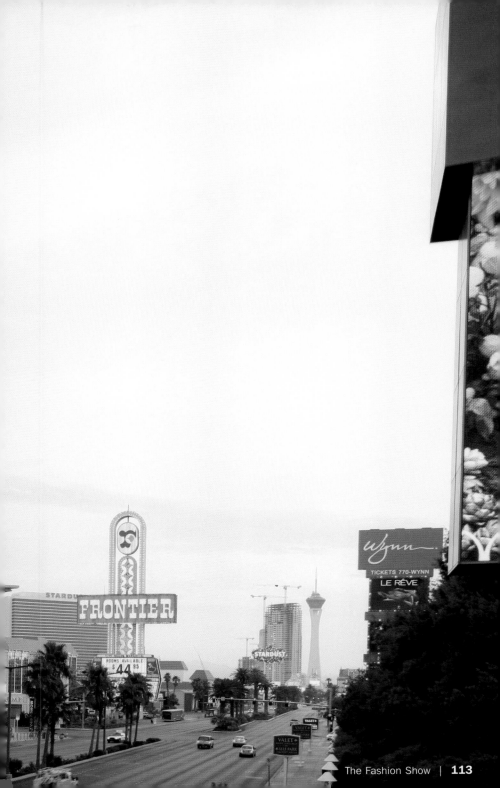

The Forum Shops

Architect: KGA
Design: Dougall Design Associates Inc.

3570 S Las Vegas Boulevard | Las Vegas, NV 89109 | Caesars Palace
Phone: +1 702 893 4800
www.forumshops.com
Opening hours: Stores Sun–Thu 10 am to 11 pm, Fri–Sat 10 am to midnight,
passage open all time
Special features: Indoor shopping center that includes high-end specialty shops, like
a 34,000-sq-ft showroom of more than 50 exotic cars and motorcycles

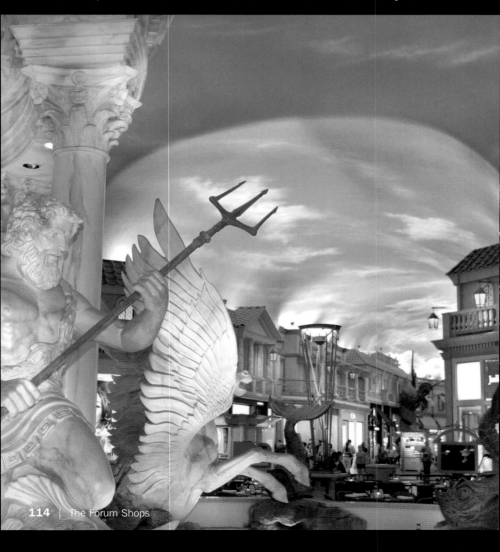

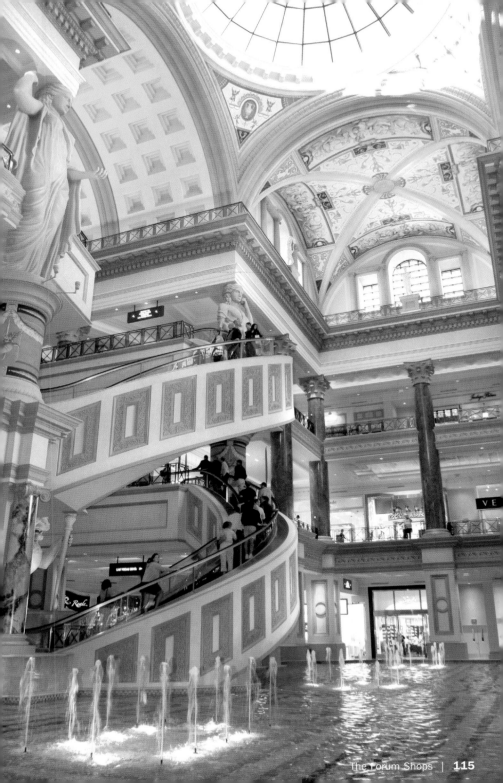

THEhotel

Design: Dougall Design Associates Inc.

3950 S Las Vegas Boulevard | Las Vegas, NV 89119 | Mandalay Bay
Phone: +1 877 632 7000
www.thehotelatmandalaybay.com
Special features: All-suite retreat offering separate living spaces furnished with
modern elegance with private bars, including 27 premium rooms up to 4,500-sq-ft

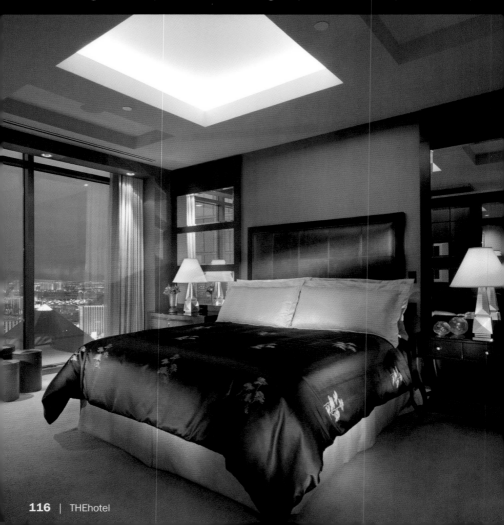

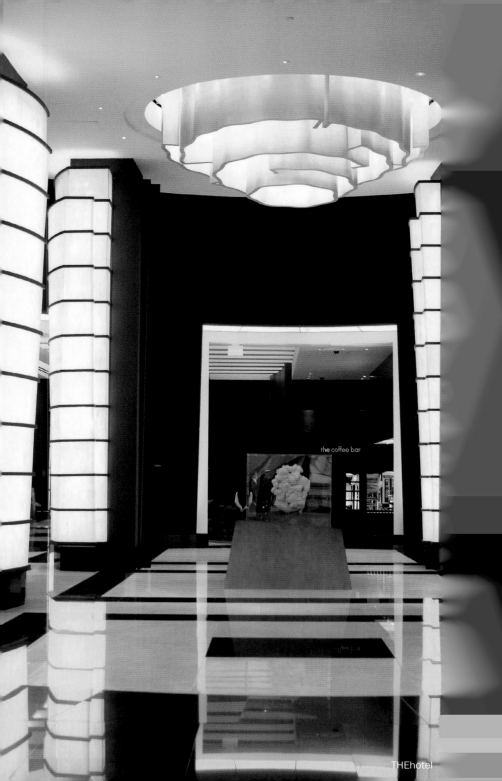

the coffee bar

THEhotel

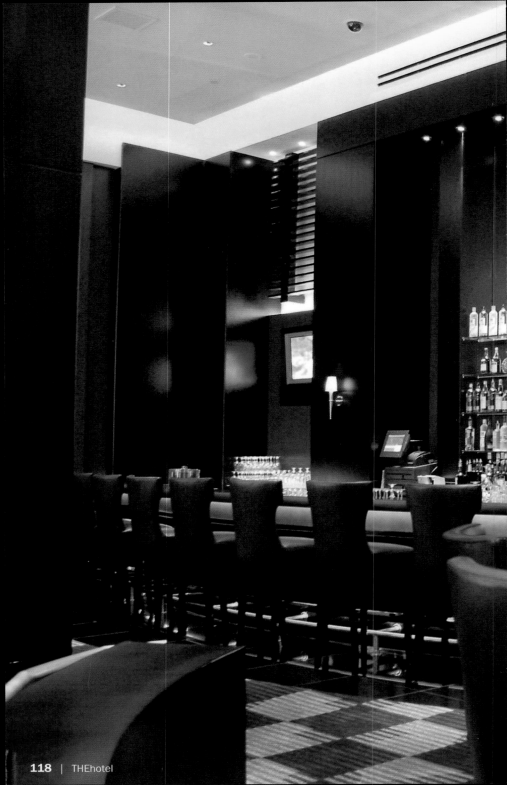

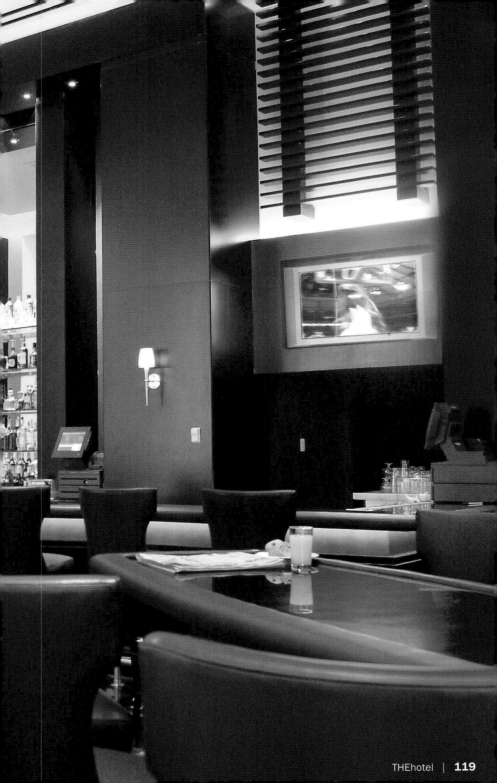

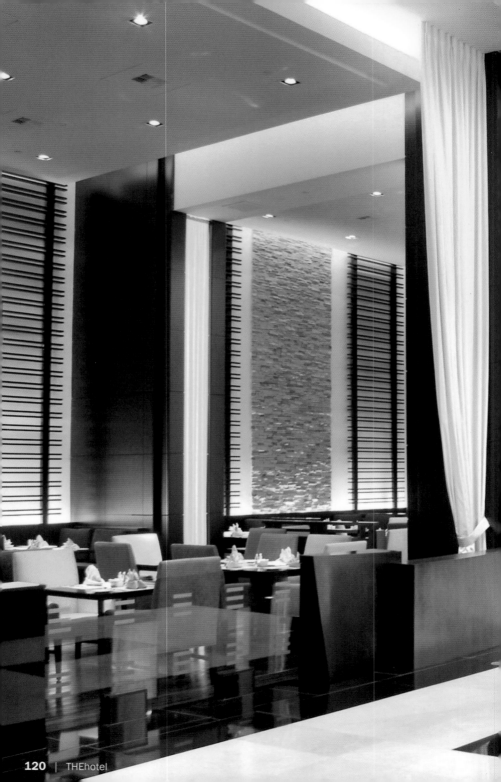

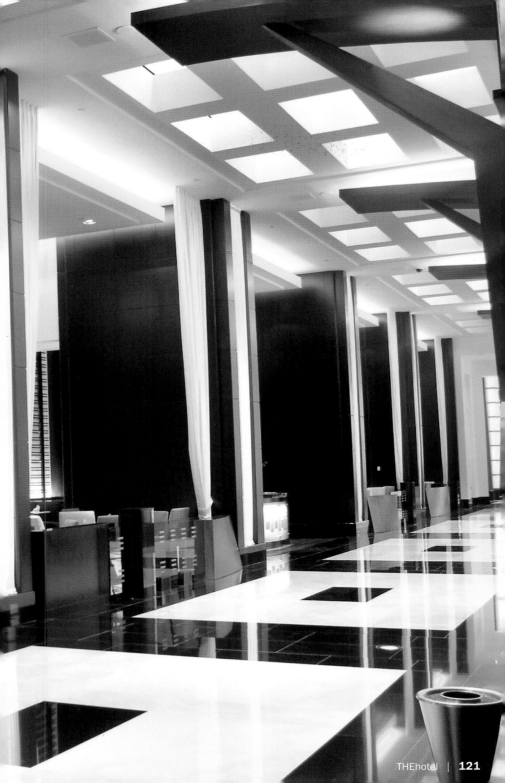

The Reading Room

Design: Cleo Design

3950 S Las Vegas Boulevard | Las Vegas, NV 89119 | Mandalay Place
Phone: +1 702 632 9374
Opening hours: Daily 7 am to 10 pm
Special features: Hushed and peaceful refuge with well-edited selection of
bestsellers to literary gems

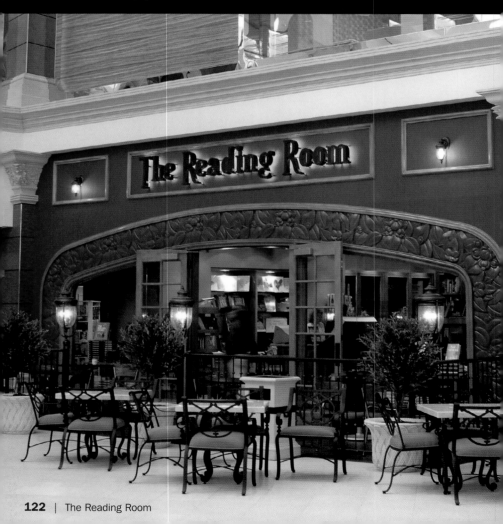

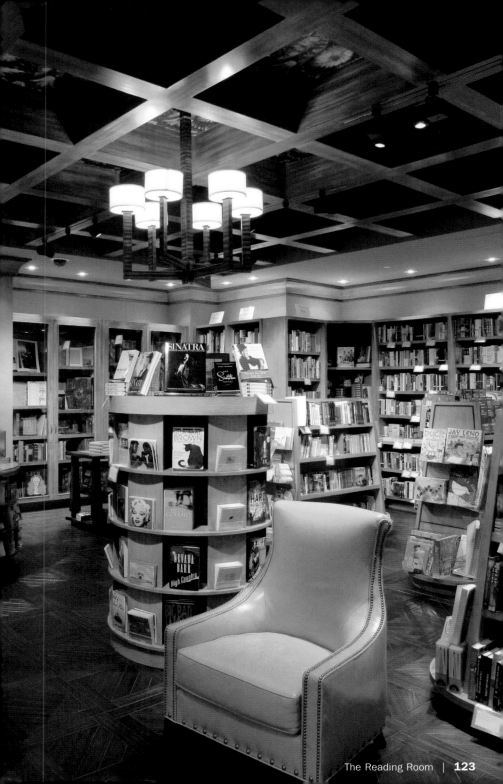

Via Bellagio

Design: Jerde Partnership International

3600 S Las Vegas Boulevard | Las Vegas, NV 89109 | Bellagio
Phone: +1 702 693 7111
www.bellagio.com
Opening hours: Stores daily 10 am to midnight, passage open all time
Special features: High-end luxury shopping with elegant stores and exclusive boutiques

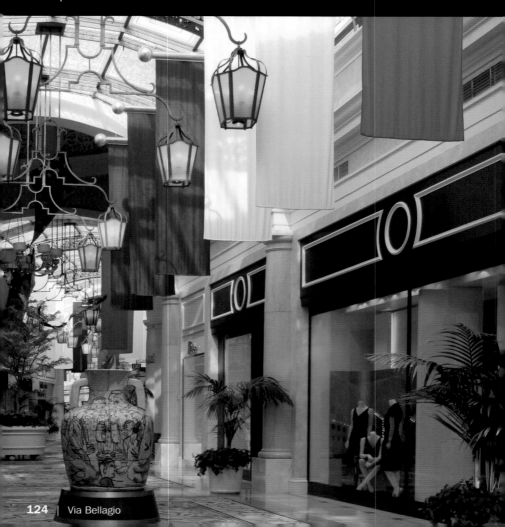

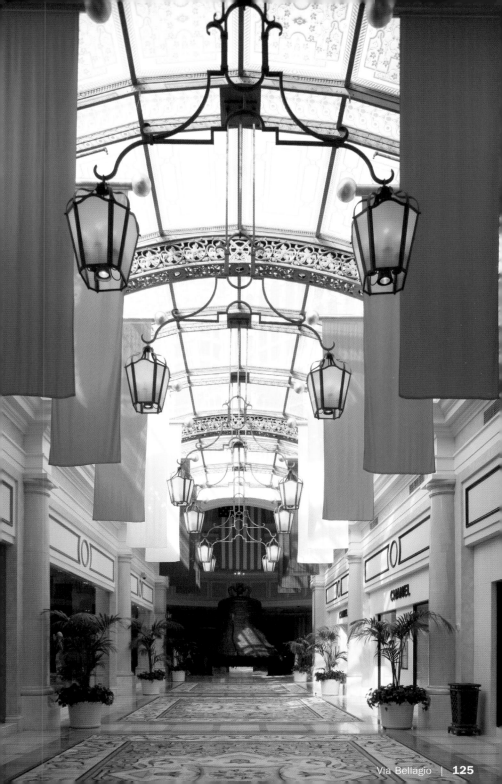

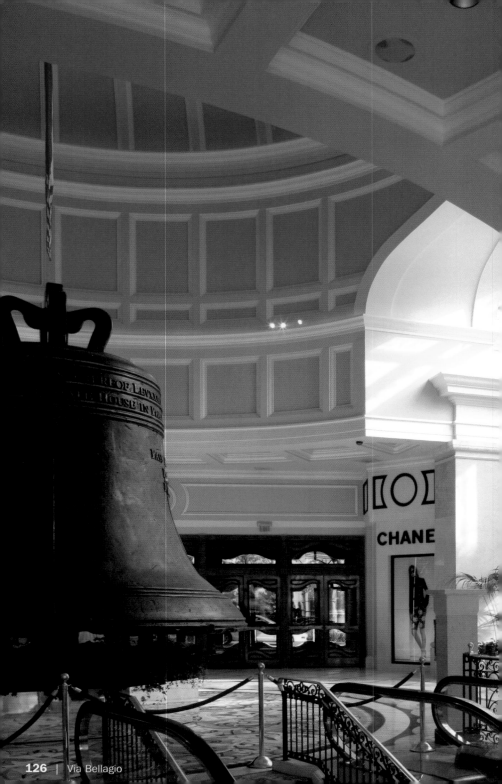

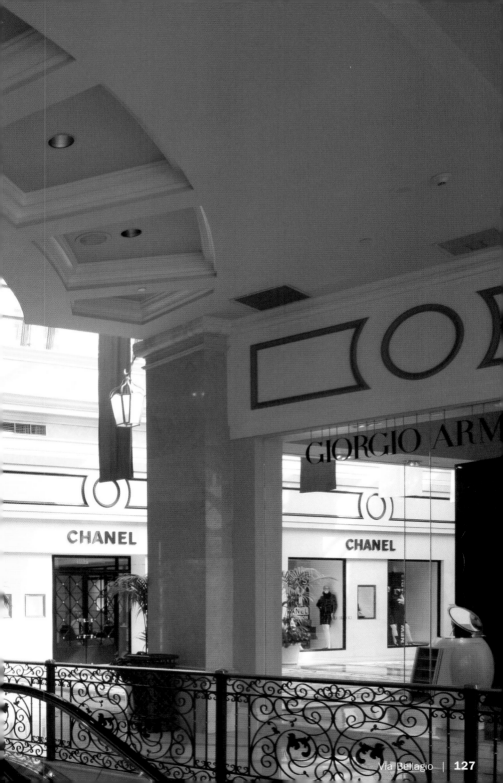

Voodoo Lounge

Design: Marnell Architecture

3700 W Flamingo Road | Las Vegas, NV 89103 | Rio
Phone: +1 702 777 7777
www.riovegasnights.com
Opening hours: Dinner daily 5 pm to 11 pm, Bar daily 5 pm to 3 am, live bands
after 9:30 pm
Special features: Stunning roof-top view from outdoor terrace on the 51st floor of
the Rio Hotel with live music nightly

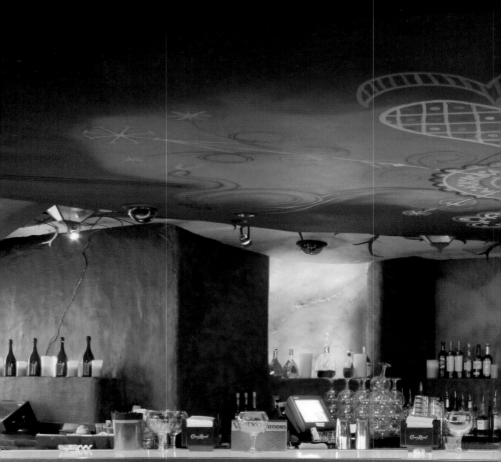

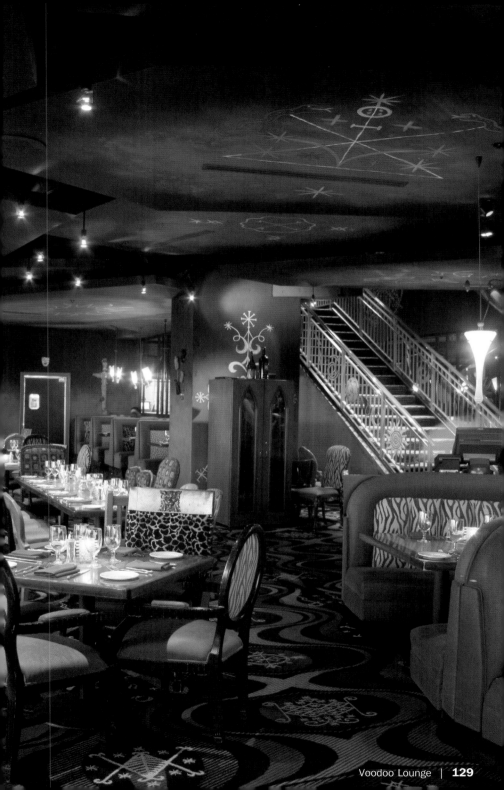

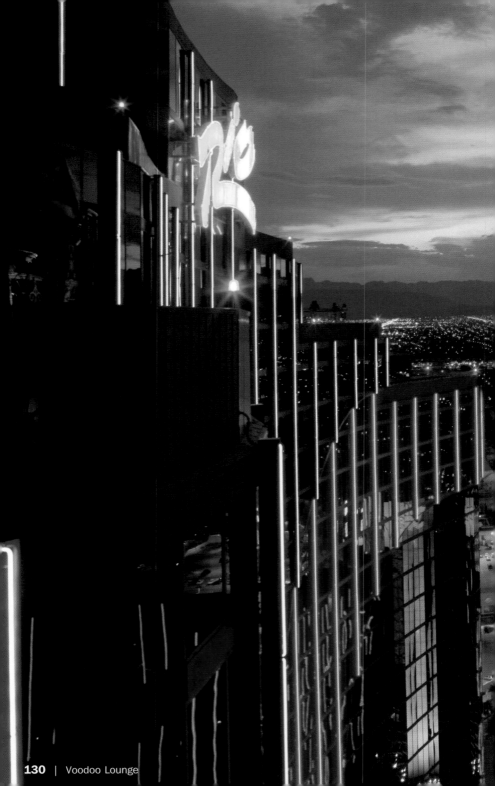

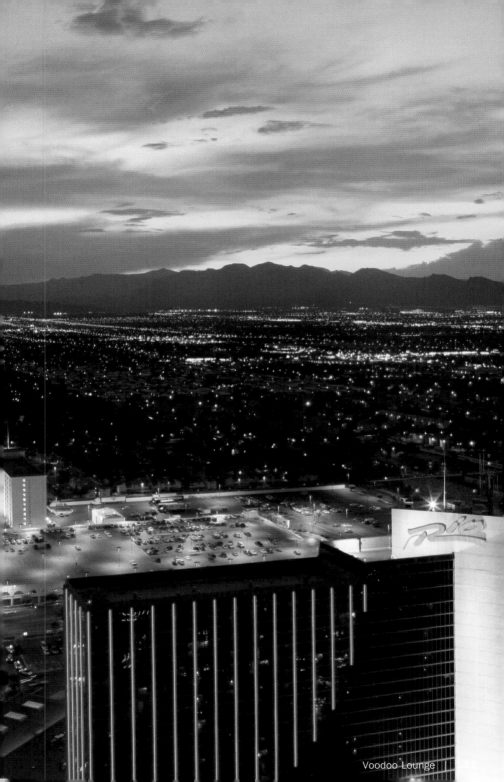

Voodoo Lounge

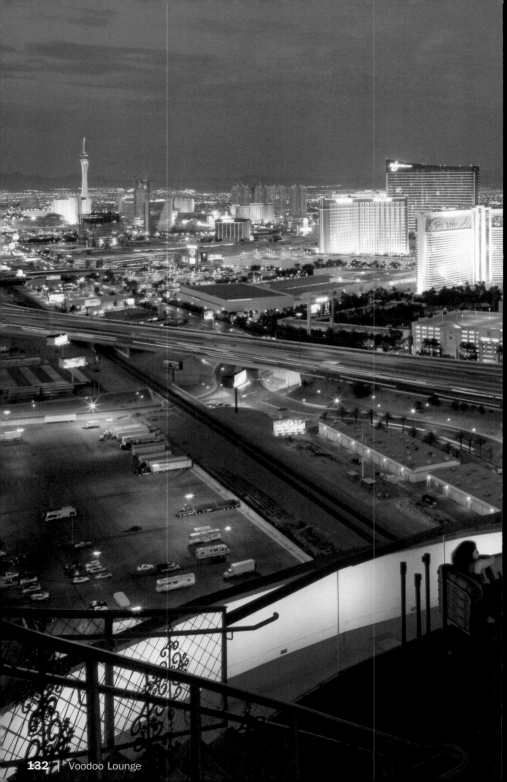

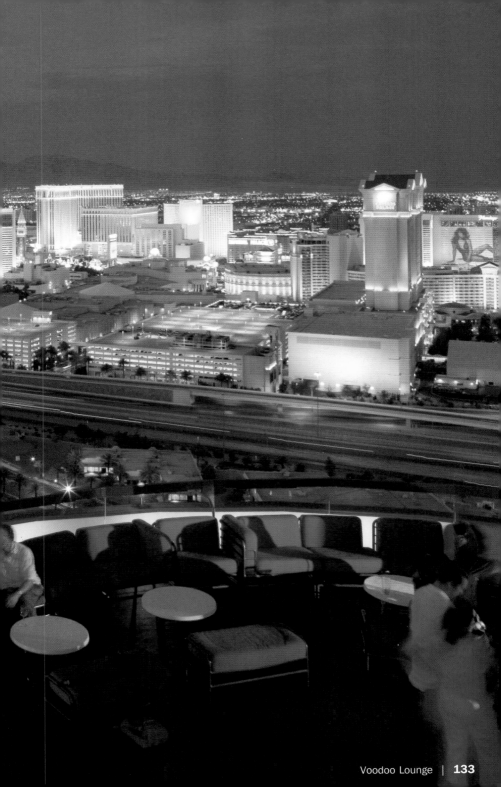

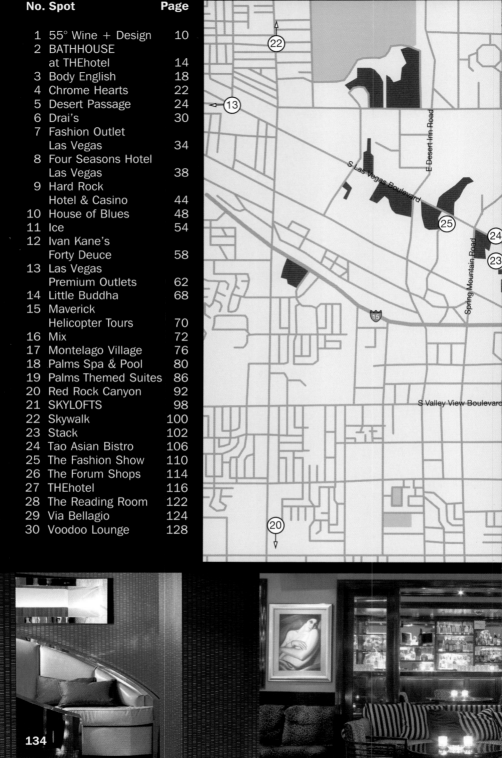

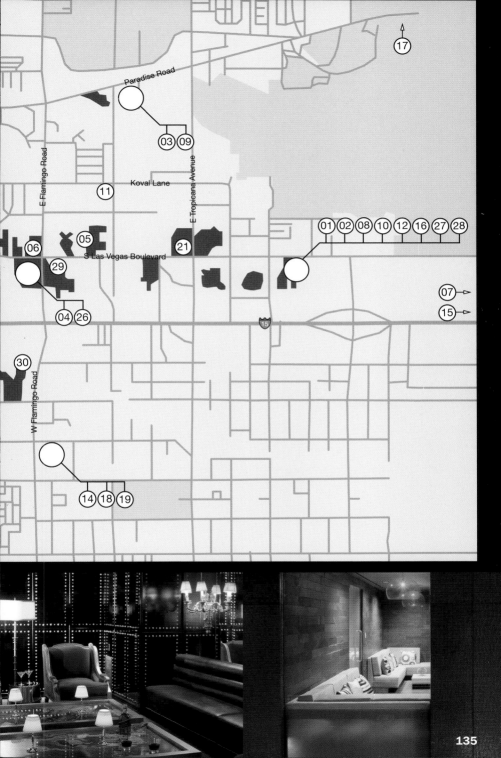

Cool Restaurants

Amsterdam
ISBN 3-8238-4588-8

Barcelona
ISBN 3-8238-4586-1

Berlin
ISBN 3-8238-4585-3

Brussels (*)
ISBN 3-8327-9065-9

Cape Town
ISBN 3-8327-9103-5

Chicago
ISBN 3-8327-9018-7

Cologne
ISBN 3-8327-9117-5

Copenhagen
ISBN 3-8327-9146-9

Côte d'Azur
ISBN 3-8327-9040-3

Dubai
ISBN 3-8327-9149-3

Frankfurt
ISBN 3-8327-9118-3

Hamburg
ISBN 3-8238-4599-3

Hong Kong
ISBN 3-8327-9111-6

Istanbul
ISBN 3-8327-9115-9

Las Vegas
ISBN 3-8327-9116-7

London 2nd edition
ISBN 3-8327-9131-0

Los Angeles
ISBN 3-8238-4589-6

Madrid
ISBN 3-8327-9029-2

Mallorca/Ibiza
ISBN 3-8327-9113-2

Miami
ISBN 3-8327-9066-7

Milan
ISBN 3-8238-4587-X

Moscow
ISBN 3-8327-9147-7

Munich
ISBN 3-8327-9019-5

New York 2nd edition
ISBN 3-8327-9130-2

Paris 2nd edition
ISBN 3-8327-9129-9

Prague
ISBN 3-8327-9068-3

Rome
ISBN 3-8327-9028-4

San Francisco
ISBN 3-8327-9067-5

Shanghai
ISBN 3-8327-9050-0

Sydney
ISBN 3-8327-9027-6

Tokyo
ISBN 3-8238-4590-X

Toscana
ISBN 3-8327-9102-7

Vienna
ISBN 3-8327-9020-9

Zurich
ISBN 3-8327-9069-1

teNeues

COOL SHOPS

BARCELONA
ISBN 3-8327-9073-X

BERLIN
ISBN 3-8327-9070-5

HAMBURG
ISBN 3-8327-9120-5

HONG KONG
ISBN 3-8327-9121-3

LONDON
ISBN 3-8327-9038-1

LOS ANGELES
ISBN 3-8327-9071-3

MILAN
ISBN 3-8327-9022-5

MUNICH
ISBN 3-8327-9072-1

NEW YORK
ISBN 3-8327-9021-7

PARIS
ISBN 3-8327-9037-3

TOKYO
ISBN 3-8238-9122-1

COOL SPOTS

LAS VEGAS
ISBN 3-8327-9152-3

MALLORCA/IBIZA
ISBN 3-8327-9123-X

MIAMI/SOUTH BEACH
ISBN 3-8327-9153-1

Size: 14 x 21.5 cm
5 1/2 x 8 1/2 in.
136 pp, Flexicover
c. 130 color photographs
Text in English, German, French
Spanish, Italian or (*) Dutch